INFINITY
NET

The Autobiography
of Yayoi Kusama

Infinity Net

—

The Autobiography of Yayoi Kusama

—

Translated by
Ralph McCarthy

First published in Japanese in 2002
First published in English in 2011 by order of the Tate Trustees
by Tate Publishing, a division of Tate Enterprises Ltd, Millbank,
London SW1P 4RG
www.tate.org.uk/publishing

Paperback edition first published 2013

Reprinted 2016, 2017 (twice)
Reprinted with revisions 2021, 2022, 2023

A catalogue record for this book is available from the British Library
ISBN: 978 1 84976 213 7

Designed by Guénola Six
Cover designed by Esterson Associates
Printed & bound by Cambrian Printers, UK

Front cover: Yayoi Kusama in her studio, Tokyo, © Yayoi Kusama

Photo credits: Fuji Television Gallery, Tokyo 1982 © ANZAÏ pp.214,
234; Minoru Aoki p.107; Stan Goldstein, New York p.191; Thomas
Haar p.131; Eikoh Hosoe p.124; Lock Huey p.41; Andre Morain p.61;
Hal Reiff p.50

Contents

—

Introduction

—

Frances Morris

In 1993, aged sixty-four, Yayoi Kusama represented Japan at the forty-fifth Venice Biennale with a riveting presentation of over twenty works, including iconic spotted pumpkin sculptures and a mirrored room installation, choreographing and broadcasting a unique style and a flare for public appeal developed over a long career. For many of us who visited Venice that summer it was a first encounter with an artist who has continued to captivate and confound us ever since. The arc of Kusama's career – her journey from east to west and back again and the evolution of her practice and persona, from studio painter to creator of a global brand – is a compelling and singular version of the history of modern art and its expanding horizons, and a vivid demonstration of how individuals shape our collective experience and our understanding of our own time.

Written in Japan in the 1970s, and drawing on diaries, letters and published texts from her earlier life, amplified by reflections composed much later, *Infinity Net* is the story of a remarkable woman and her extraordinary life and career. Kusama's episodic narrative presents itself as a series of adventures. She plots her career from her family life and childhood years in pre-war rural Japan to the dazzling modernity of Manhattan in the 1960s, where she found acclaim and a degree of notoriety within a decade. From this early success in New York she retreated suddenly back to Japan and to obscurity, only to emerge again, reinvented, as a global icon for the twenty-first century.

Kusama was born in Matsumoto, a provincial mountain town west of Tokyo in Nagano Prefecture, into a traditional and conservative-minded family. Her pursuit of an artistic career was as unwelcome (to her family) as it was unlikely. With all the odds stacked against her – family, gender, race, era – this powerfully determined young woman was clearly conscious of what it would take to achieve her ambition, and was willing to risk pretty much everything. In the absence of support from family or teachers, Kusama developed her nascent talent through auto-didactic means. Following her precocious mastery of traditional Nihonga painting she explored western-style painting techniques, absorbing and reinventing formal and technical innovations of European and American avant-garde art, creating a profusion of drawings and paintings and

—

delivering a sequence of solo exhibitions that brought her considerable critical acclaim as early as the mid-1950s. Knowing that the constraints of post-war Japan would constrict her freedom of movement, and encouraged by the legendary American artist Georgia O'Keeffe, she departed for the United States, arriving in New York via Seattle in 1957. There she hit the ground running, absorbing and responding to the tempo and scale of the New York art scene in an outpouring of vast 'Infinity Net' paintings, monochrome expanses of repeated small brushstrokes that were to become her signature style.

Despite the warm critical reception she received in New York, she was propelled by a seemingly insatiable desire to challenge both herself and her public. She moved rapidly into work in three dimensions – soft sculpture, photographic collage, installation, filmmaking, performance and body art – exploring subject matter often at the extreme edge of conventional mores even in an age of sex, drugs and rock 'n' roll. Unwilling to comply with the restrictions of working in a studio, Kusama expanded her practice to embrace adventures in political activism, fashion design, publishing and counter-cultural commercial 'entertainment'. In an era of clearly marked boundaries between media and styles, sharp delineation between private and public spheres, and embedded hierarchies in terms of gender and race, Kusama's totalising practice was beyond the comprehension of all but the most astute of her contemporaries.

Perhaps because images and forms are their chosen means of expression, visual artists' autobiographies are relatively rare. In fact, for much of the last century both artists and art historians of modernism have played down the relevance of lived experience – whether of viewer or artist – to the meaning and experience of the work of art itself, privileging form over content and 'inspiration' over influence. In an intimate and confessional manner Kusama speaks of her huge ambition, the ebb and flow of her mental health and her relentless obsessions, anxieties and hallucinatory experiences, and the struggle to find suitably expressive vehicles for the public manifestation of deeply private experiences. *Infinity Net* also offers an unflinching critique of the art establishment, details intimate portraits of artists who shared and shaped her life, and intermissions of poetry and portrait photography. At a moment when we are beginning to acknowledge the relevance of biography and cultural context in more fully accounting for art's expansive meanings, as well as for the formation of the artistic 'canon', revisiting Kusama's work through the lens of her own lived experience feels especially timely.

—

This is not the work of old age reflecting on youth, as is so often the case with autobiographical memoir. It was, for the most part, written by Kusama in Japan in the 1970s, at a moment of self-reflection when writing had briefly eclipsed image-making as her principal creative outlet. It has a rawness and immediacy that makes it an invaluable source for scholars and admirers alike. Threaded through the story we find evidence, in abundance, of Kusama's own skill at managing (and marketing) her own destiny. For much of her life she was her own gallerist and producer, press officer, product developer, event manager, publisher and agent. Alongside her work as an artist she designed fabric and fashion, hosted and staged ticketed performances, wrote plays, novels, and poetry. From early in her career she commissioned leading photographers to stage and record her practice, with acute attention to dress (and at times undress). This book can itself be seen as part of a life-long, self-styled and highly successful strategy of blending personal revelation with self-promotion and personal branding, terms that more appropriately speak to an era of global digital communication and social media.

Infinity Net was first published in Japanese in 2002, almost thirty years after Kusama wrote the first draft, and four years after her triumphant 'return' to the USA with the landmark exhibition organised in Los Angeles surveying her work from 1958–68. The exhibition *Love Forever* travelled to New York, Minneapolis and on to Tokyo, and generated the first wave of a Kusamania that has spread widely and wildly ever since. Her retrospective at Tate Modern in 2012 – the occasion for the first edition of this English translation – was followed by countless dazzling international touring shows, of old and new work, commissions and re-enactments, revelations and consolidations. These shows have criss-crossed the globe through physical and digital means, creating provocative, moving and compelling, indeed immersive, experiences for audiences the world over, and have revealed, in their reception, an enduring desire shared by millions to connect with Yayoi Kusama in her own infinite universe.

—

Prologue

—

In Year One of the new millennium, from 2 September to 11 November, the city of Yokohama became the stage for a groundbreaking art festival.

The main venues were the Pacifico Yokohama Exhibition Hall and Red Brick Warehouse No. 1, but the entire city was involved. Exhibitions were held at museums, public halls, and galleries throughout the town, and some hundred and ten artists from thirty-eight countries around the world participated. YOKOHAMA 2001: *International Triennale of Contemporary Art* was Japan's first-ever large-scale festival of this sort. And it was to be held every three years from then on.

Since the 1960s, when I was based in New York, I have exhibited my work all over the world, circling the globe many times. And I have always wondered why Japan lags so far behind. Japan has the money and the facilities but no real interest in or understanding of contemporary art. I was shocked, when I first returned from the USA, to find that my country seemed a good hundred years behind the times.

Subsequently, whenever I have returned from a trip abroad, it has felt as though it is to a new Japan. But we're still behind the times, even today. There is so much room for improvement in every facet of the art world and the museum system here. During the years of Japan's economic bubble in the late 1980s , for example, money was wasted on all sorts of frivolities while art museums across the country were struggling for funds. Such foolishness is never seen in America, even during the leanest of times. Americans and Europeans have a more deeply rooted understanding of the importance of the arts. In Japan, art is thought of only as an amusing pastime, if not an extravagance. This creates an environment that suppresses any real progress and gives rise to a purely superficial view of the arts.

But now, in 2001, the country was lending its support to a huge international exhibition of contemporary art—a happy development indeed. The main theme of the exhibition was 'MEGA WAVE – Towards a New Synthesis'. All conceivable genres of contemporary art were being brought together – painting, sculpture, photography, film, installation. The dream was to create a tsunami of art capable of swallowing the entire world. How wonderful it would be for Yokohama, Japan to be the epicentre of such a mega-wave!

I presented both indoor and outdoor installations at this our

—

historic first Triennale. My indoor installation was called *Endless Narcissus Show*. Inside the Pacifico Yokohama Exhibition Hall I constructed a mirror room. Ten enormous mirrors lined the interior surfaces of the room, and suspended from the ceiling and covering the floor were some fifteen hundred metallic mirror balls. Walking into the room, viewers found themselves reflected in the countless surfaces and transforming endlessly as they moved. This was an immersion experience in Repetitive Vision.

The outdoor installation was titled *Narcissus Sea*. I floated two thousand mirror balls, each exactly 30cm in diameter, in the canal alongside the train tracks in the New Port district. As I installed the work, each ball met the water with a joyful sploosh! I found it extraordinarily moving. The mirror balls bobbed and rolled in the waves. Light glinted off them, and their perfectly spherical surfaces reflected the sky and the clouds and the surrounding water and landscape. Onlookers watched an endless, silvery sea of mirrors bubble into existence. The ceaseless movement of the water pushed the globes together and pulled them apart with gentle clicks and squeaks, constantly transforming the shape of the work. It was a startling but dazzling sight: a mysterious sort of entity reproducing endlessly at the water's edge.

It is said that the Japanese still think of art as something far removed from daily life. And it is certainly true that contemporary art has yet to fully blossom here.

Historically, the port of Yokohama was the first location in Japan opened to foreign influence, and clearly it still leads the way in that respect. It is extremely significant, I think, that Japan's first major international exhibition of contemporary art was presented here, and on such an unprecedented scale. I wish we could see it happen not just triennially, but every year.

I wanted to celebrate a new beginning for contemporary art in Japan with that sea of shining mirror balls. And to celebrate, as well, the beginning of the twenty-first century.

Thinking back, I have travelled a long road to get here. My constant battle with art began when I was still a child. But my destiny was decided when I made up my mind to leave Japan and journey to America.

Part 1

—

To New York

—

My Debut as
an Avant-garde
Artist

—

1957/1966

Reckless Journey

I landed in America on 18 November 1957.

Like others of the generation that grew up during the Pacific War, I had not studied any English at school; yet I felt no trepidation whatsoever about my first trip overseas. I had been dying to leave Japan and escape the chains that bound me.

In those days, however, there were still limits on the amount of foreign currency you could take out of the country. I had therefore decided to take sixty silk kimonos and some two thousand of my drawings and paintings. My plan was to survive by selling these.

I shall never forget my very first flight, on that aeroplane to America. The cabin was empty except for two American GIs, a war bride, and me.

Back then, no one travelled abroad in the lighthearted spirit you find today. There were all sorts of obstacles, many of which seemed almost insurmountable. First among the obstacles for me was my family's opposition. It took me eight full years to convince my mother to let me leave Japan.

My hometown is Matsumoto City, in Nagano Prefecture. Matsumoto is surrounded by the towering peaks of the Japanese Alps and the sun hides behind the western mountains early each afternoon. I used to wonder what lay beyond those daylight-swallowing mountains. Was there just a sheer precipice, and nothing else? Or was something there after all, something I knew nothing about? If so, what?

This childhood curiosity about unknown places developed eventually into a desire to see with my own eyes the foreign lands that were said to lie far beyond those rugged mountains. One day, I addressed a letter to the president of France:

> *Dear Sir, I would like to see your country, France.*
> *Please help me.*

—

I hardly expected the short but kindly reply that soon arrived:

> *Thank you for your interest in our country. There are various organizations devoted to cultural exchange between France and Japan. I have arranged for information to be sent to you. Your first task, however, is to study our language and pass the examination. I wish you every success.*

And, indeed, the French Embassy later proved most generous with information and advice. But, oh, what headaches that infernal language gave me!

After much fretting and indecision, I turned my attention to the other country I was dying to visit back then: America. I recalled the face of a little Black girl with braided hair I had seen in a picture book. In a vast country like that, where such children lived, I might find wonders I had never seen before. That was the place for me! Deeply transparent blue skies over fields of more grain than anyone could ever eat; green meadows soaking up the sunlight; empty spaces extending endlessly in every direction ... How I longed to see such things with my own two eyes! I wanted to live there. If I had trouble making a living, maybe I could become a farmer and paint on the side. Come what may, I decided, I would go to America.

How to get there, though? How to get to a country where I had absolutely no connections? America had its own laws limiting the expatriation of dollars, and you could not even enter the country in those days without a sponsor's letter guaranteeing your livelihood. I pondered this problem and then pondered it some more.

Soon after the War ended, in a secondhand bookshop in Matsumoto, I found a book of paintings by Georgia O'Keeffe. I have no idea why such a book was available in a provincial city like Matsumoto, but my discovery of it was the thread that led me all the way to America. Gazing at O'Keeffe's paintings, I somehow felt that she was someone who might help me if I went to the United States. She was the only American artist I knew anything about, and until this point all I knew was what I had heard from a friend – that she was the most famous painter in the USA. And yet, right then and there, I decided to write her a letter.

A six-hour train ride got me to Shinjuku, in Tokyo. I went straight to the American Embassy and leafed with trembling hands through their copy of *Who's Who*, looking for O'Keeffe's address. I was thrilled when I found it. (I never dreamed that one day I myself might be listed in the same book.)

—

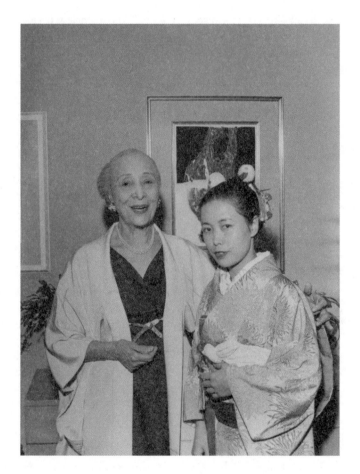

With Zoe Dusanne
Dusanne Gallery, Seattle
1957

—

Georgia O'Keeffe stood at the pinnacle of the American art world. She was considered one of the top three female artists of the twentieth century, and she was the wife of Alfred Stieglitz, one of the pioneers of American photographic art. She had fled the hustle and bustle of New York and retreated to a mountain ranch in the mysterious rock-strewn region of New Mexico, where she painted pictures of scattered cattle bones and lived like a spiritual recluse. It was to her that I wrote, as soon as I got back to Matsumoto, of my desire to go to America at all costs. I enclosed several of my watercolours, even as I told myself I was mad to think she might ever reply.

Astoundingly, though, Georgia O'Keeffe wrote back to me. I couldn't believe my luck! She had been kind enough to respond to the sudden outburst of a lowly Japanese girl she'd never met or heard of before. And this was only the first of many encouraging letters she was to send me.

Her reply made me all the more determined to go to the USA, but I still needed to find an American sponsor. This was no easy task. As a last resort I contacted a distant relative, a former Minister of State and Vice-Minister of Foreign Affairs named Etsujiro Uehara, asking if he could introduce me to someone. He put me in contact with an old friend of his, the widow of a Mr Ota who as a first-generation immigrant in the USA had established a bank in Seattle and consulted for hotels and other businesses. Mrs Ota agreed to be my sponsor. With the invaluable cooperation of many people, not least the eminent psychiatrists Dr Yushi Uchimura and Dr Shiho Nishimaru, I was finally able to obtain a visa. My official 'purpose' in going overseas was to hold a solo exhibition of my art in Seattle.

To help cover travel expenses I changed a million yen into dollars at the Tokyo branch of an American company called Continental Brothers. This was of course against the law. In those days, a million yen was enough money to build several houses. I smuggled those few thousand dollars out of the country by sewing some of the bills into my dress and stuffing others into the toes of my shoes.

Seattle was the first American city I set foot in. The owner of Seattle's Zoe Dusanne Gallery, who had helped debut such artists as Mark Tobey and Kenneth Callahan, had offered to exhibit my work.

I knew no one in Seattle apart from Mrs. Ota, whom I had met previously in Tokyo, and George Tsutakawa, a sculptor who taught art at the University of Washington. I knew that I had sealed a very challenging fate for myself. I was starting out on a crazy new life and was bound to run into trouble at every turn. But the joy I felt at finally

—

arriving in America, after painstakingly piecing together every possible connection, far outweighed any anxiety about the hardships ahead.

In December 1957 the Dusanne Gallery staged my first solo show in the USA. Included were twenty-six watercolours and pastels, including *Spirit of Rocks, Ancient Ceremony, Ancient Ball Gown, Fire Burning in the Abyss, Flight of Bones,* and *Small Rocks in China.* I was featured on a radio programme called Voice of America to talk about the exhibition, as well as my impressions of the United States.

The exhibition was a resounding success. But I thought of Seattle as only the first step in my reckless journey. My final destination had always been New York; having reached the foot of the mountain, I wanted to climb to the top. The people in Seattle urged me to stay, but I felt I had no choice but to leave them behind and set out on the next adventure.

A Living Hell
in New York

The aeroplane was tossed by heavy rain and lightning. Things got so rough flying over the Rocky Mountains that I was sure it was the end. As the plane bounced and shuddered, I reflected that somewhere down below was New Mexico and the quiet ranch Georgia O'Keeffe had invited me to visit. When at last we landed at the airport in New York, I felt as if I had narrowly escaped with my life. Almost unconsciously, I found myself reciting the prayer my friends in Seattle had said before every meal and every cup of coffee: 'Dear Lord, we thank You for blessing us with this sustenance, and for Your loving guidance in preserving the happiness we feel today.'

The first place I stayed in New York was the Buddhist Society, a hostel for foreign students who supposedly practised Zen. I was there about three months before going out on my own, renting a room in a house and later a loft. Rent was cheap, but this was at the beginning of a decline in America's fortunes. By the time President Kennedy made his call for a 'New Frontier Spirit', the tremendous cost of the Vietnam War had set the country on a downward spiral. Food prices went up and up; and unlike post-war Matsumoto, New York was in every way a fierce and violent place. I found it all extremely stressful and was soon mired in neurosis.

Compared to Seattle, this city felt like hell on earth. Spending all my time on my work and studies, I soon burned through what dollars I had. And before I knew it I was living in abject poverty. It was one struggle after another: getting enough food to make it through the day; scraping together cash for canvas and paints; problems with Immigration about my visa; illness… Many of the studio's windows were broken. My bed was an old door that someone had left out on the street, and I had just one blanket. The loft was in an office building in the business district, and the steam heating was turned off at six o'clock in the evening. New York is almost as far north as Sakhalin Island, and I froze to the bone and developed pain in my abdomen. Unable to sleep, I would get out of

bed and paint. There was no other way to endure the cold and the hunger. And so I pushed myself on to ever more intense work.

One day someone knocked at my studio door. Standing there was a not-yet-famous Sam Francis, who lived in the next building. I made some coffee and when I served him a cup he asked if I had any milk. I blushed, not knowing what to say. I had no food of any sort, and had not eaten since the previous evening. In fact, it was something of a miracle that I even had coffee.

Dinner in those days might be a handful of small, shrivelled chestnuts given me by a friend. Sometimes I would gather discarded fish heads from the fishmonger's rubbish and carry them home in my rag bag, along with the rotting outer leaves of cabbages tossed out by a greengrocer. I would boil these into soup in a ten-cent pot from the junk shop and thus fend off starvation for another day.

Sometimes, when I felt miserable, I would make my way to the top of the Empire State Building. From there the vast, dazzling panorama of New York, the citadel of capitalism, with its glittering jewels and grand, swirling drama of praise and blame, still retained something of America's golden age, the pre-Vietnam era of prosperity and abundance. Looking down from the world's greatest skyscraper, I felt that I was standing at the threshold of all worldly ambition, where truly anything was possible. My hands are empty now, but I shall fill them with everything my heart desires, right here in New York. Such longing was like a roaring fire inside me. My commitment to a revolution in art caused the blood to run hot in my veins and even made me forget my hunger.

One day about this time, an elderly woman came to call on me at my studio. Georgia O'Keeffe, visiting New York, had been concerned enough to take the trouble to stop by and see how I was getting along. Face to face with the legendary artist whose painting of cow bones I had discovered in a secondhand bookshop in provincial Japan, I wondered if I was dreaming.

O'Keeffe was determined to help me and introduced me to Edith Halpert, her own art dealer, with whom she had worked throughout her career. At her Downtown Gallery, Halpert had debuted such eminent artists as Yasuo Kuniyoshi, John Marin, and Stuart Davis. She bought one of my works.

Pouring virtually every penny I had into materials and canvas, I painted and painted. I set up a canvas so big that I needed a stepladder to work on it, and over a jet-black surface I inscribed to my heart's content a toneless net of tiny white arcs, tens of thousands of them.

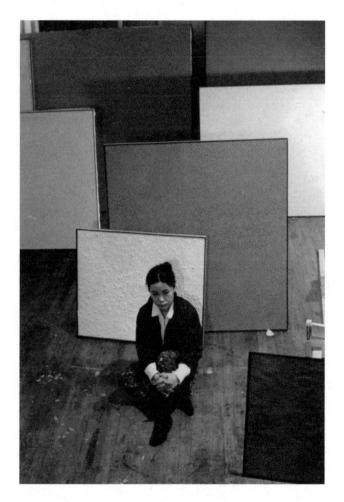

In my studio
New York
c.1960

—

I got up each day before dawn and worked until late at night, stopping only for meals. Before long the studio was filled with canvases, each of which was covered with nothing but nets. In time my friends grew uneasy and peered at me with anxious eyes. 'Yayoi, are you all right?' they'd ask, genuinely concerned. 'Why are you painting the same thing every day?'

In fact, I often suffered episodes of severe neurosis. I would cover a canvas with nets, then continue painting them on the table, on the floor, and finally on my own body. As I repeated this process over and over again, the nets began to expand to infinity. I forgot about myself as they enveloped me, clinging to my arms and legs and clothes and filling the entire room.

I woke one morning to find the nets I had painted the previous day stuck to the windows. Marvelling at this, I went to touch them, and they crawled on and into the skin of my hands. My heart began racing. In the throes of a full-blown panic attack I called an ambulance, which rushed me to Bellevue Hospital. Unfortunately this sort of thing began to happen with some regularity, until I was arriving at the hospital in an ambulance every few days. The doctors would see me and roll their eyes as if to say, 'You again?' Finally I was told that they did not treat illnesses like mine at Bellevue. They advised me to get psychiatric help and said I would have to enter a mental hospital.

But I just kept painting like mad. Even eating became secondary to painting. Living in the most expensive city in the world, which seemed to devour any money I could get my hands on, I often lacked even fifteen cents for a bus fare, and sometimes my stomach did not see food for two days in a row. But still I painted for all I was worth.

Anxiety felt like flickering flames in my bones... A female Bodhidharma sitting cross-legged on this great rock called New York, the bastion of Americanism... At times I wished I had a bright red sports car to race down the highway at a crazy speed beneath the deep blue sky. I wouldn't care if I crashed into a tree. Give me enough crisp dollars, and I would buy a boundless expanse of grassy plains somewhere in Texas, just for myself.

That was not all I dreamed of. I wanted to have fun the way that some of my friends did, night after night, with one boy after another, all with different faces and skin colours – black, white, yellow, brown. I kept dreaming these dreams, thinking how desperately I wanted to be rich and muttering to myself that fame would not be bad either. As far as such longings went, I was no different from the throng of nameless youths who had made their way to New York.

—

—

But reality was the hard crust of bread on my table, the torn stuffed dog on my couch. And the 'white nets' that led me all the way to the mental institution – what good were they doing me? Any number of times I thought of putting my foot right through those canvases.

One day I carried a canvas taller than myself forty blocks through the streets of Manhattan, in order to submit it for consideration for the Whitney Annual. The Whitney is cutting-edge now, but in those days it was hopelessly conservative, and even as I lugged my painting along I was telling myself that there was no chancethe director of that museum would understand my work. As expected, my painting was not selected, and I had to carry it forty blocks back again. The wind was blowing hard that day, and more than once it seemed as if the canvas would sail up into the air, taking me with it. When I got home I was so exhausted I slept like the dead for two days.

Action Painting was all the rage then, and everybody was adopting this style and selling the stuff at outrageous prices. My paintings were the polar opposite in terms of intention, but I believed that producing the unique art that came from within myself was the most important thing I could do to build my life as an artist.

Taking my Stand
with a Single
Polka Dot

In October 1959 I achieved my dream of a solo exhibition in New York. The show was titled *Obsessional Monochrome* and held at the Brata Gallery, downtown on 10th Street. 10th Street was where De Kooning and Klein and other leaders of the New York School, whose influence is still so strong today, had their studios. The show consisted of several white-on-black infinity net paintings that ignored composition and had no centres. The monotony produced by their repetitive patterns bewildered the viewer, while their hypnotic serenity drew the spirit into a vertigo of nothingness. These pictures presaged the Zero Art movement in Europe as well as Pop Art, which originated in New York and was to become the dominant trend of abstraction there.

My desire was to predict and measure the infinity of the unbounded universe, from my own position in it, with dots – an accumulation of particles forming the negative spaces in the net. How deep was the mystery? Did infinite infinities exist beyond our universe? In exploring these questions I wanted to examine the single dot that was my own life. One polka dot: a single particle among billions. I issued a manifesto stating that everything – myself, others, the entire universe – would be obliterated by white nets of nothingness connecting astronomical accumulations of dots. White nets enveloping the black dots of silent death against a pitch-dark background of nothingness. By the time the canvas reached 33ft it had transcended its nature as canvas to fill the entire room. This was my 'epic', summing up all that I was. And the spell of the dots and the mesh enfolded me in a magical curtain of mysterious, invisible power.

One day an artist who had found success in Paris and become renowned around the world called at my studio. This ebullient Frenchman, a savvy self-promoter who had gained and maintained popular success thanks to his agility at leaping from trend to trend, seemed to live only to win all the awards he could get his hands on. He berated me. 'Yayoi! Look outside yourself! Don't you want to listen to Beethoven or Mozart? Why don't you read Kant and Hegel? There's so much greatness out there!

—

How can you repeat these meaningless exercises, day and night, for years? It's a waste of time!'

But I was under the spell of the polka dot nets. Bring on Picasso, bring on Matisse, bring on anybody! I would stand up to them all with a single polka dot. That was the way I saw it, and I had no ears to listen. I was betting everything on this and raising my revolutionary banner against all of history.

Even so, it was hard to believe the sensation this first solo exhibition in New York created, or the sudden success it brought. A number of respected critics were generous with their praise.

Yayoi Kusama at the Brata Gallery, 89 East 10th Street, is a young Japanese painter currently working in New York. Her paintings are puzzling in their dry, obsessional repetitions. They are huge white canvases, lightly scored with gray dots and partly washed over again with a white film. The results are infinitely extending compositions utterly dependent on the viewer's patient scrutiny of the subtle transitions in tone. Her exhibition is without question a striking tour de force, but disturbing none the less in its tightly held austerity.
(Dore Ashton, *New York Times*, 23 October 1959)

This stunning and quietly overwhelming exhibition is likely to prove and remain the sensation of a season barely a month old ... The observer will encounter vast meshes of white which form a net over a darker ground whose contrast has been stopped down by a final diluted coat of white. The net is written in over the surface in small, roughly rectangular movements, with modulations in its porosity and the texture of the paint setting up as many subtle variations of movement and pattern as the eye wishes to compose. A gentle radiance imbues the surface with great dignity ... Having labored for ten years over many 'tests' to arrive at this moment, Miss Kusama would seem to possess the required patience and, ultimately, the flexibility to extend one of the most promising new talents to appear on the New York scene in years.
(Sidney Tillim, *Arts Magazine*, October 1959)

—

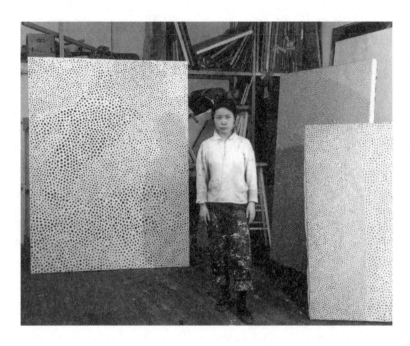

In my studio
New York
c.1960

Donald Judd was my first close friend in the New York art world, and he was the first to buy one of the pieces in the exhibition. He was kind enough to write that

> *Yayoi Kusama is an original painter. The five white, very large paintings in this show are strong, advanced in concept and realized. The space is shallow, close to the surface and achieved by innumerable small arcs superimposed on a black ground overlain with a wash of white. The effect is both complex and simple ... The total quality suggests an analogy to a large, fragile, but vigorously carved grill or to a massive, solid lace. The expression transcends the question of whether it is Oriental or American. Although it is something of both, certainly of such Americans as Rothko, Still and Newman, it is not at all a synthesis and is thoroughly independent.*
> (Donald Judd, *Art News*, October 1959)

But allow me to revisit, in my own words, the works I exhibited at Brata.

In these paintings a static, undivided, two-dimensional space adheres to the flat canvas in the form of contiguous microscopic specks that follow one another endlessly, forming a tangible surface texture that expresses a strangely expansive accumulation of mass. The layers of dry white paint, which result from a single touch of the brush repeated tirelessly over time, lend specificity to the infinity of space within an extraordinarily mundane visual field.

The endlessly repetitive rhythm and the monochrome surface, which cannot be defined by established, conventional structure or methodology, present an attempt at a new painting based on a different 'light'. Moreover, these pictures have totally abandoned a fixed focal point or centre. I originated this concept myself, and it had been prominent in my work for more than ten years.

Deep in the mountains of Nagano, working with letter-size sheets of white paper, I had found my own unique method of expression: ink paintings featuring accumulations of tiny dots and pen drawings of endless and unbroken chains of graded cellular forms or peculiar structures that resembled magnified sections of plant stalks. During the dark days of the War, the scenery of the river bed behind our house, where I spent much of my disconsolate childhood, became the miraculous source of a vision: the hundreds of millions of white pebbles, each individually verifiable, really 'existed' there, drenched in the midsummer sun.

But with or without such direct revelations from the natural world, in the images of my own psyche, even in the midst of unfocused motivation and meaningless accident, I seem drawn toward a most strange and curious realm. I wanted to liberate myself from this 'unknown something', to pluck my spirit from the Stygian pools of emotion and fling it beyond eternity. And now, at last, I had set that spirit free in the very chaos of the vacuum.

A singular current had wound its way through the thousands of pictures I had made, gradually gathering force, blossoming even in negative expression and establishing itself over the course of a decade as my artistic identity. I was now ready to present this monument to the world.

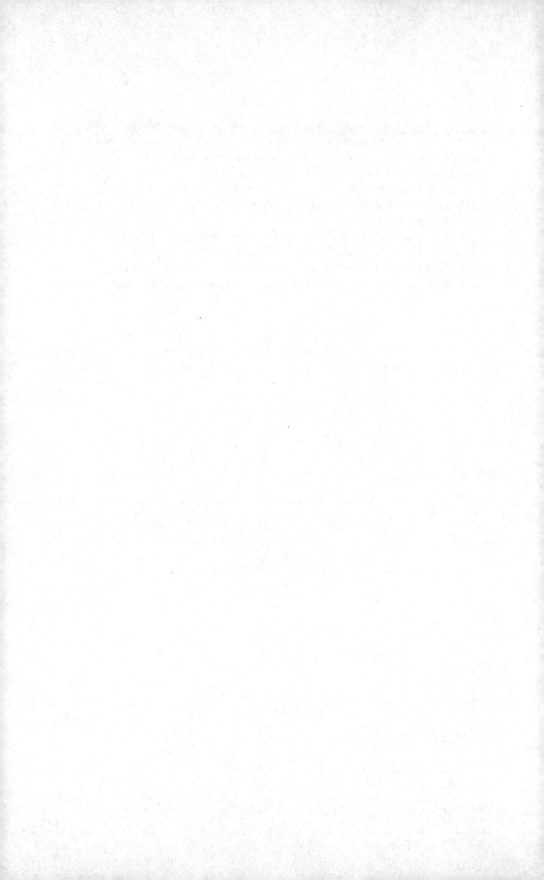

A Successful Debut

I debuted in New York with just five works – monochrommatic and simple, yet complex, subconscious accumulations of microcosmic lights, in which the spatial universe unfolds as far as the eye can see. Yet at first glance the canvases, which were up to 14ft in length, looked like nothing at all – just plain white surfaces.

The Brata Gallery, the stage for this debut, was an unimposing little place with a sloping ceiling, scarcely more than a basement room. Just outside, winos lay about in foul-smelling alleyways, but this was the famous 10th Street, lined with the studios of renowned American artists. It was like downtown's den of resistance to the uptown museum district.

At the time, I was in a delicate position because my visa had expired. America made things difficult for visitors, and the exhibition was, ironically, a chance event upon which the fate of my stay in the country might hinge. I prayed as if my life depended on it. Never before had I prayed for anything so vulgar as the success of a solo exhibition, but that is how desperate my circumstance as an alien had left me feeling.

As I had hoped and predicted, the crowd at the opening overwhelmed the little gallery. It was wall-to-wall people, with many of New York's leading artists showing up one after the other. This was the ultimate result under the worst possible conditions, and afterwards, on the wino-strewn street, my close friends cheered and lifted me into the air, shouting, 'Yayoi, you've finally done it!' I will never forget my many American friends who helped and supported me through all the difficult times. Their open-hearted friendship was one of the most precious things America gave me.

As a result of the sensational Brata exhibition, I received letters from Germany and France and cities across the USA. Suddenly I could advance my work and see it accepted and understood by international society.

—

A month later I opened another exhibition, at the Nova Gallery in Boston. This gallery was the largest in New England, with vast stretches of wall space that I filled with scores of works. These included watercolours, but most prominent were ten white-on-black net paintings, each of them 10ft in length.

> *I was extremely impressed by the paintings of Yayoi Kusama, a young Japanese who is making her debut locally at the Nova Gallery ... Miss Kusama's idiom is decidedly Japanese in its reticence and confinement to black and white; and she has original things to say in abstract-expressionist terms.*
>
> *At first glance her painting resembles gigantic structures of lace, but if one examines what appears to be variations on a formal theme, the subtlety and distinction of her visual imagination becomes more and more vivid. She works on a large scale, with no specific center of balance, whorls of white pigment meshing into dense or light textures against a black ground. It has the effect somewhat of a net floating on the ocean, a veil shimmering across reality.*
> (Robert Taylor, *Boston Sunday Herald*, 6 December 1959)

Four months after this I exhibited at the Gres Gallery, the most international of the galleries then in Washington, DC. The exhibition was titled *Infinity Nets* and comprised dozens of red and white net variations that filled the entire space. Directors and affiliates of Washington museums, critics, politicians, government officials, and ambassadors from countries all over the world came to see it, and many shook my hand and told me how moved they were by the work.

> *The work of Yayoi Kusama at the Gres Gallery is a far cry from traditional modes of expression. A self-taught artist who has evolved entirely alone, the artist has moved from pastels which are delicate interpretations of nature to her present group of large abstractions, based entirely on the repetition of a simple, circular brush-stroke...*
>
> *Little remains of the traditional Japanese approach except the scrupulous attention to detail and the disciplined and controlled technique. Only such an artist as Mark Tobey or Jackson Pollock in our country has gone so far in making each single and minute thread of paint count in an overall*

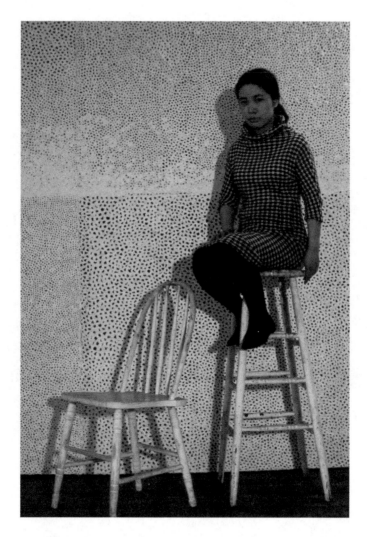

In my studio
New York
C.1961

—

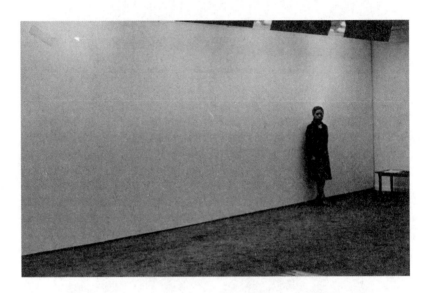

**With a 33-ft-long Infinity Net
painting (title unknown)**
Stephen Radich Gallery, New York
1961

—

composition, which must rely for its interest on infinite variety within a single unity.
(Leslie Ahlander, *Washington Post*, 1 May 1960)

During this time I was also participating in group exhibitions in New York, Boston, Washington, DC, and other cities, including the *International Watercolour Exhibition: Twentieth Biennial at the Brooklyn Museum*. I had participated in the Eighteenth Biennial in 1955 as a Japanese artist, but this time my work was in the American section. The director of the museum, John Gordon, was extremely gracious and helpful to me, for which I am still most grateful.

I also exhibited works at the *Monochrome Malerei* exhibition at the Städtisches Museum in Leverkusen, West Germany. This was planned by Udo Kultermann, highly respected in Europe for his architectural theories and art criticism. Such artists as Lucio Fontana, Yves Klein, and Piero Manzoni participated, and Mark Rothko and I represented the United States. This was an experimental, avant-garde exhibition treating the most important trends in international painting, and I contributed three white-on-black nets.

In May 1960, two years after I had arrived in New York and thanks to the success of the Washington, DC exhibition a month earlier, I signed an exclusive contract with the Stephen Radich Gallery in Manhattan. A year later, in May 1961, I held my fifth US solo exhibition, and the largest yet, at the Radich Gallery. I presented monochrome works that included collages, watercolours, and oils of enormous size – nets on canvases measuring 10, 20, and even 35 ft. Again, the exhibition received praise from a number of critics:

> *Yayoi Kusama is a young Japanese whose debut on 10th Street attracted attention a couple of years ago. Over a dark ground she applies white or red, stroking the paint so as to leave small cell-like apertures through which the ground is seen. Miss Kusama paints with intensity, which may help to explain why the pictures lack any trace of ponderosity or rhetoric.*
> (Jack Kroll, *Art News*, May 1961)

> *[Kusama's] large, clear, and spacious canvases are ... vastly detailed. Most of them are white on a slightly darker background, though some are red and of contrasting tonality. A native Japanese who lives in New York, her concern is for*

a process of all-over detail repeated with purity of tone and nicely decorative. Somewhere in her experience may have been networks of vast detail. But, while the paintings are very much alike in this respect, subtle variations in the imagery are perceptible with concentration.
(Carlyle Burrows, *New York Herald Tribune,* 5 May 1961)

Economy of means is carried both literally and figuratively to great lengths in Yayoi Kusama's non-objective paintings. Her typical picture is capable of infinite enlargement and consists of an expanse of creamy paint, here and there ruffled by wavelets and dotted evenly with tiny dark pebble shapes. The patience that has gone into the confection of this texture is astonishing and the concentrated pattern titillates the eye.
(Stuart Preston, *New York Times,* 7 May 1961)

And so I was steadily consolidating my position in the avant-garde of New York, the pulsing centre of radical art. I marvelled at my luck.

As for the art scene in the city at that time, the Action Painting of the New York School still held sway, even though Jackson Pollock had been dead for ten years. Action Painting was in one sense an extremely dynamic attempt to face the complexity of modern life head-on, and to break through to something new. But transcendence of the times was to remain out of reach even for the reigning American king – the glorified and no longer young De Kooning – to say nothing of the followers of Pollock. It was clear to all that the New York School, which had prospered alongside the commercialisation of art, now needed to break new ground. But it was not easy for the young international talent gathering in New York to extricate itself from the spell of Action Painting.

This was more than just a problem in the field of art; it reflected a wider dilemma of human nature in the context of modern civilisation. Even those ostensibly new schools of thought that arose to oppose the New York School only embraced, in the end, nostalgia for artists like Mondrian or Kandinsky; they were incapable of moving so much as a single step beyond historical theory. Nor did Neo-Dadaism fall outside this paradigm. The truth is that, at the time, there was not even the hint of any renaissance or rising tide that would define the century. Nor was it easy to imagine that we were approaching some sort of critical mass. The only thing certain was that the future was up to us, the younger generation.

—

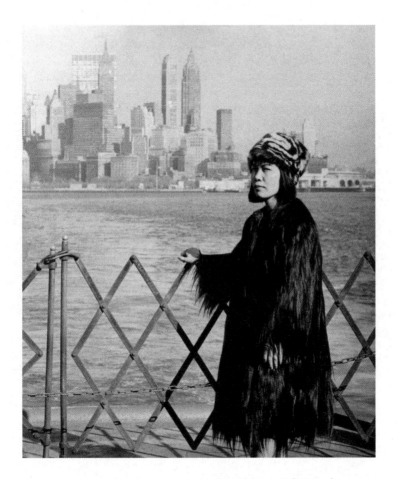

**In Brooklyn with Manhattan
view**
New York
1964

—

—

In my studio
New York
1958–9

—

I wasn't surprised that New York was awash with '-isms', but more daunting was the fact that the struggle for survival was such a powerful component of everything. The city was saturated with the possibility of great good fortune but also harboured a bottomless quagmire of shame and blame. And the heartless commercialism of many art dealers was too terrible even to joke about; it was a cause of real agony for many creative artists.

In a place like this, it was not only singers and Broadway actors who were climbing the stairway to empty fame – fame of the sort you read about in cheap novels. For those who chose the easy path up, however, the way down was even faster. But because New York was the sort of place it was, there were also many artists with true backbone – robust people who could not be broken. And these artists were doing good work.

Sometimes, when I was tired of working, I would go to the Museum of Modern Art. Standing before the great pageant of art history, I would gaze on the works that have survived beyond their times, analy-sing and evaluating them as if trying to solve mathematical puzzles, attempting to assess them in the context of the societies and times that had engendered them; but then I would return to myself and, in trying to consider the next starting point for my work, always find myself faced with the difficulty of reading my own future.

From the point of view of one who creates, everything is a gamble, a leap into the unknown. Like tens of thousands of artists before me, I was being drawn towards a mountain peak that has never been mapped or climbed. If the true shape of this peak had been knowable, my life would have turned to grey. Each day I learned anew what an inscrutable, ambition-filled human struggle it is to paint, to create. I had still only grasped the first small clues to fashioning forms, and there was no guarantee that I would not throw it all out and start again from scratch tomorrow. This was my state of mind as, one day at a time, I continued to create.

—

Phallic Soft Sculptures

—

From around 1961 something new appeared in the world of my art. It came to be known as 'soft sculpture'. The nets I was painting had continued to proliferate until they had spread beyond the canvas to cover the tables, the floor, the chairs, and the walls. The result of the unlimited development of this obsessional art was that I was able to shed my painter's skin and metamorphose into an environmental sculptor.

I first exhibited soft sculptures in October of 1962, in a group show at Green Gallery in New York. The pieces I presented were an armchair and an eight-legged sofa painted white and completely covered with phallus-shaped protuberances of stuffed cloth. It was because of this group exhibition that Green Gallery, which had been founded the previous year by Richard Bellamy, came to be known as 'ground zero' for Pop Art in New York.

The work contributed to this exhibition by Claes Oldenburg was a man's suit made of stiff papier-mâché. Later, when I went to see some new work by Oldenburg and it turned out to be numerically themed soft sculptures, his wife, Pat, pulled me aside and said, 'Yayoi, forgive us!'

In December 1963, I had a solo exhibition at the Gertrude Stein Gallery in New York titled *Aggregation: One Thousand Boats Show.* This was my first installation. Countless white, stuffed and sewn phalluses completely covered a full-size rowing boat. All around the boat, on the ceiling and walls, were 999 black-and-white poster-size photos of it. When you stood in this room, the thousand boats would begin to spin around you, leaving you seasick and hallucinating.

> *Around the spot-lit boat, the aggregation of single images again papering the walls comes back at one like a series of telescoped echoes.*
> *This genuine, obscurely poetic event should not be dismissed as a surrealist caper. Kusama has produced an object and an environment that are weirdly moving.*
> (Brian O'Doherty, *New York Times,* 29 December 1963)

—

—

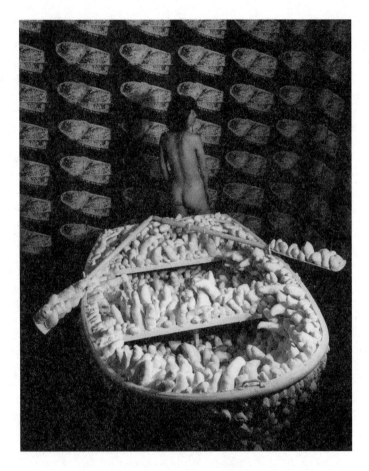

*Aggregation: One Thousand
Boats Show*
Gertrude Stein Gallery, New York
1963

—

—

Accumulation No.2
Group show
Green Gallery, New York
1962

—

Andy Warhol came to the opening and shouted, 'Yayoi, what is this?' His next words were, 'It's fantastic!' A few years later, when Andy papered the ceiling and walls at the Leo Castelli Gallery with silkscreen posters of a cow's face, it was plainly an appropriation or imitation of my *Thousand Boats Show*.

The reason my first soft sculptures were shaped like penises is that I had a fear of sex as something dirty. People often assume that I must be mad about sex, because I make so many such objects, but that's a complete misunderstanding. It's quite the opposite – I make the objects because they horrify me.

I began making penises in order to heal my feelings of disgust towards sex. Reproducing the objects, again and again, was my way of conquering the fear. It was a kind of self-therapy, to which I gave the name 'Psychosomatic Art'.

In any case, I was terrified of sex, and of the phallus. My fear was of the hide-in-the-closet-trembling variety. And it was precisely because of this that I made tons and tons of these shapes. Creating them, putting myself right in the midst of the horror, helped me to heal the wounds in my heart and, little by little, escape the fear. Each day I would produce forms that scared me, piling them up by the thousands and tens of thousands. It was only by doing this that I gradually turned the horror into something familiar.

By continuously reproducing the forms of things that terrify me, I am able to suppress the fear. I make a pile of soft sculpture penises and lie down among them. That turns the frightening thing into something funny, something amusing. I'm able to revel in my illness in the dazzling light of day. By now, the number of penises I have made easily reaches into the hundreds of thousands.

My fear of sex has its basis in my education and the environment I grew up in. I was taught that sex was dirty, shameful, something to be hidden. Complicating things even more was all the talk about 'good families' and 'arranged marriage', and the absolute opposition to romantic love. I wasn't even allowed to speak freely with boys.

Also, I had happened to witness the sex act when I was a toddler, and the fear that entered through my eyes had ballooned inside me, along with a raging anxiety about the future. Because this was within the family, the child that I was could not help carrying around feelings she could not cope with. All the inner factors that cause me to perceive sexual intercourse as violence find form in the shape of the male sex organ.

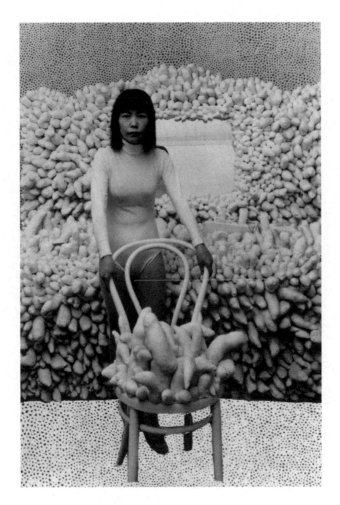

Photo collage
Sex Obsessional Chair
1962

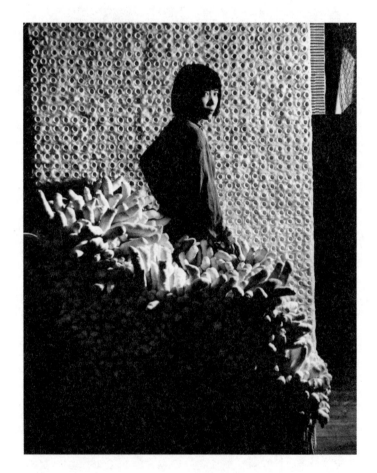

With *Accumulation No.1* and
egg-carton relief, *No.B,3*,
in my studio
New York
c.1963–4

—

I hate and fear violence and war. Humankind has tried many different approaches to these problems, but they just will not disappear from the world. Ultimately, behind the impulse to fight is the simple fact that men have penises. And because of this some men will never stop perpetrating wars and violence.

I first brought the themes of sex and food to the contemporary American scene with my Psychosomatic Art. Like sex, food was also an object of fear for me and therefore an appropriate subject. Macaroni was the medium I chose to give concrete expression to this powerful fixation of mine.

We live surrounded by food of a sort that reaches us via automats and conveyor belts. In order to live, we have no choice but to eat such food. Humans gobble up machine-produced food endlessly. Just to think of consuming, over time, thousands of servings of macaroni, is horrifying to me and sets off an overwhelming obsession. That is why I made macaroni sculptures with my own hands – in an attempt to overcome the fear.

—

Create,
then Obliterate

Artists do not usually express their own psychological complexes directly, but I do use my complexes and fears as subjects. I am terrified by just the thought of something long and ugly like a phallus entering me, and that is why I make so many of them. The thought of continually eating something like macaroni, spat out by machinery, fills me with fear and revulsion, so I make macaroni sculptures. I make them and make them and then keep on making them, until I bury myself in the process. I call this 'obliteration'.

For example, by covering my entire body with polka dots, and then covering the background with polka dots as well, I find self-obliteration. Or I stick polka dots all over a horse standing before a polka-dot background, and the form of the horse disappears, assimilated into the dots. The mass that is 'horse' is absorbed into something timeless. And when that happens, I too am obliterated.

Here, the ground – or the mesh of the net – is negative, and the polka dots placed upon the ground are positive. In the case of phallic soft sculptures, the protrusions are positive and the spaces between them negative. The positive and negative become one and consolidate my expression. And that is when I achieve obliteration.

I went on finding new ways to turn my obsessions into concrete forms. In my solo *Driving Image Show* at the Richard Castellane Gallery in New York in April 1964 I used the Psychosomatic Art I advocated to express my sex and food obsessions. I covered panties, shirts, coats, shoes, phallic objects, and many other things with mass-produced macaroni, and cast infinity nets over vases, tables, kitchen utensils, and shoes, giving concrete shape to such ideas as *Form of Perseveration*, *Compulsion Furniture*, *Obsession Room*, *Propagating Visions*, *Air Obsession*, and *Food Carpet*.

All of these emerged from the image of a tablecloth engulfing a telephone. The flower pattern on the cloth spilled over onto the telephone, climbed the door in the background, and continued to proliferate,

adhering to the walls and ceiling. The floor was wall-to-wall macaroni. Two dogs wearing macaroni coats were set loose to dash around frantically, barking and weaving between the legs of high-heeled women who shrieked as they trod the macaroni floor.

The *New York Times* said that I had broken new ground, and called the exhibition a 'must-see'. Subsequently, the show was taken on the road not only in the United States but throughout Europe, where I gained many new supporters. I crossed the Atlantic a lot in those days.

I will never forget Sir Herbert Read, eminent British poet and renowned critic of art and literature, coming to the show in New York. Born in North Yorkshire, Sir Herbert was in the USA as a visiting lecturer at Wesleyan University and travelled all the way from Connecticut to see my work, about which he was extremely enthusiastic.

Sir Herbert and I had been introduced by Beatrice Perry quite some time before, and he had attended my 1960 *Infinity Nets* exhibition in Washington, DC. He had selected me to participate in the 1960 *Contemporary American Painting* exhibition at the Gres Gallery and had consistently provided me with support, assistance, and encouragement. This is the statement he submitted for the 1964 *Driving Image* show:

> *I discovered Kusama's art in Washington, several years ago, and at once I felt that I was in the presence of an original talent. Those early paintings, without beginning, without end, without form, without definition, seemed to actualize the infinity of space. Now, with perfect consistency, she creates forms that proliferate like mycelium and seal the consciousness in their white integument. It is an autonomous art, the most authentic type of super-reality. This image of strange beauty presses on our organs of perception with terrifying persistence.*

My food-and-sex images created a gradual storm in the New York art world of the 1960s. Meanwhile, my work was steadily acquiring a more three-dimensional or spatial character, and soon I was making use of mirrors and plastics. This trend burst into full bloom for my solo exhibition at the Castellane Gallery in November of 1965, *Infinity Mirror Room – Phalli's Field*.

The walls of the room were mirrors, and sprouting from the floor were thousands of white canvas phallic forms covered with red polka dots. The mirrors reflected them infinitely, summoning up a sublime,

—

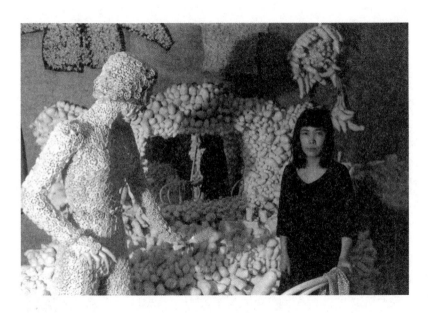

Driving Image Show
Castellane Gallery, New York
1964

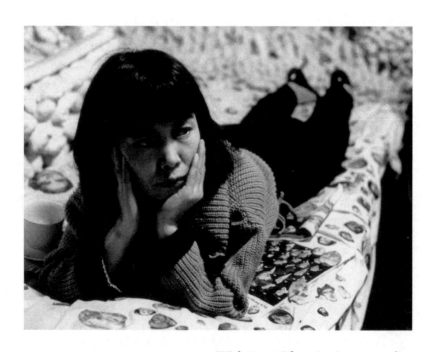

With *Face Obsession* in my studio
New York
1964

miraculous field of phalluses. People could walk barefoot through the phallus meadow, becoming one with the work and experiencing their own figures and movements as part of the sculpture. Wandering into this infinite wonderland, where a grandiose aggregation of human sexual symbols had been transformed into a humorous, polka-dotted field, viewers found themselves spellbound by the imagination as it exorcised sexual sickness in the naked light of day.

The next stage of my mirror series, *Kusama's Peep Show* (or *Endless Love Show*), opened at the same gallery in March, 1966. The show contained no paintings or sculptures, but consisted of a single multimedia installation – a mirror room with coloured electric lights. The room was a hexagon with mirrors covering the interior walls, floor, and ceiling. Embedded in the ceiling were small red, white, blue, green, and yellow light bulbs programmed to blink incessantly in changing patterns as music played. I gave each visitor a badge that said 'LOVE FOREVER'. In the brochure for this exhibition, I wrote:

> Endless Love Show 1966 *is about Mechanization, Repetition, Obsession, Impulse, Vertigo, and Unrealized Infinite Love. I prefer the title* Kusama's Peep Show *for this exhibition, because it allows you to see things that you can not touch.*

The many-coloured lights in the ceiling blinked at a furious speed in seventeen different, constantly changing patterns. These psychedelic images made the work a kind of kaleidoscope, mirroring the light at the root of all things and luring anyone who entered the room towards madness. This was the materialisation of a state of rapture I myself had experienced, in which my spirit was whisked away to wander the border between life and death. I gave this enormous environmental sculpture the title *Love Forever* because I intended it as an electric monument to love itself. The show was an immediate sensation.

This was my living, breathing manifesto of Love. Thousands of illuminated colours blinking at the speed of light – isn't this the very illusion of Life in our transient world? In the darkness that follows a single flash of light, our souls are lured into the black silence of death. The kaleidoscope of our lives and joys, and the great, radiant drama of human life: a paper-thin instant, dependent upon denial and disconnection at one-second intervals. The psychedelic lights of a moment ago – were they a dream? An illusion? *This* is Shangri-La.

On an Endless
Highway

To jump back a bit, in April of 1965 I presented my *Aggregation: One Thousand Boats* show in the group exhibition *Nul 1965* at the Stedelijk Museum in Amsterdam. The exhibition included work by Lucio Fontana, Yves Klein, Piero Manzoni, Enrico Castellani, and Henk Peeters.

Later that year, Gordon Brown, the chief editor of *Art Voices*, published an article titled 'Yayoi Kusama, The First Obsessional Artist' in a Japanese art magazine:

> *Americans think of Japanese girls as hothouse flowers. For this reason, Kusama surprises them. She is rugged and strong – a veritable human dynamo of creative energy and artistic achievement.*
>
> *Nevertheless, Americans are right in comparing her to full bloom in works that have either fascinated, shocked or won the admiration of people of three continents.*
>
> *For this event, she had a room all to herself ... About two hundred journalists, art critics and dealers came to the official opening at the Stedelijk Museum. These visitors all interviewed Kusama who came from New York specially for the occasion. The visitors were charmed by Kusama's vivacious manner and intrigued by her unusual attire which consisted of red tights and shoes and jet-black coat of gorilla fur exactly matching the color of her hair.*
> (Gordon Brown, *Gendai Bijutsu*, November 1965)

Even Japanese art journalism, which had been completely ignoring me, began little by little to take note of my existence:

> *In considering artists currently active in New York, one must not overlook Yayoi Kusama. In a first-rate gallery on Madison Avenue, her name immediately came up at the*

mention of Japanese artists. She attaches profusions of white, potato-like, stuffed objects to boats, chairs, and mannequins. Having made her way to New York seven years ago, Kusama gained the recognition of Herbert Read and is being widely shown throughout the United States, and in Europe as well.
(Morio Shinoda, *Bijutsu Techo,* April 1965)

From the end of 1965 to the beginning of 1966 I stayed in Milan, devising my plans for an outdoor installation to present at the Thirty-third Venice Biennale, which was to begin in June. Lucio Fontana was most supportive of me during this time, allowing me access to his studio in Milan and assisting in my project even to the point of helping me with financing. In return, I presented him with a *Compulsion Suitcase* covered with phalluses.

Concerning the Venice Biennale of 1966, some have reported that I attempted to participate without an invitation and was sent away, but that is not how it was. It is true that I was not officially invited, but I had spoken directly with the chairman of the committee and received his permission to go ahead with my installation.

Narcissus Garden was an environmental piece consisting of fifteen hundred plastic mirror balls covering a section of green lawn. The chairman himself had helped me install the reflective spheres, so it was hardly a 'guerrilla' operation. I stood among the mirror balls in a formal gold kimono with silver obi and handed out copies of the statement Sir Herbert Read had provided for my exhibition two years earlier.

As a comment on commercialism in the art world, I was selling the mirror balls for 1,200 lira (about $2) each, an audience-participation performance that shocked the authorities. They made me stop, telling me it was inappropriate to sell my artworks as if they were 'hot dogs or ice cream cones'. But the installation remained.

Nearly thirty years later, in 1993, Akira Tatehata became the Japanese commissioner for the Forty-fifth Venice Biennale, and I was officially invited to represent Japan. This was, of course, a moving and meaningful experience for me, but the 1966 Biennale will always remain closer to my heart, if only because back then I had to do everything on my own.

And so my artistic expression has developed, evolved, and propagated, just as it continues to do today. I feel as if I am driving an endless highway, all the way to my death. It is like drinking thousands of cups of coffee cranked out of automatic dispensing machines. And until

—

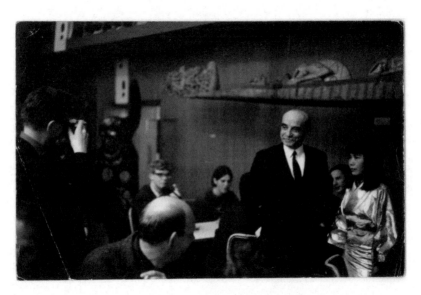

**With Lucio Fontana at the
opening of** *International Zero*
Stedelijk Museum, Amsterdam
1965

—

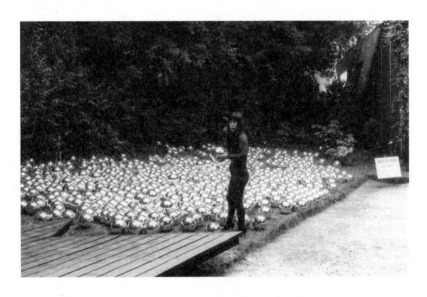

Narcissus Garden
The 33rd Venice Biennale
1966

I reach the end of my life I will, through no choice of my own, aspire to all sorts of feelings and visions, while at the same time fleeing them and seeking obliteration.

I cannot cease to be; nor can I escape death. There are times when consciousness of continuous existence drives me quite mad. Before and after creating a work I fall ill, menaced by obsessions that crawl through my body – although I cannot say whether they come from inside or outside of me.

I fluctuate between feelings of reality and unreality. I am neither a Christian nor a Buddhist. Nor do I possess great self-control. I find myself stranded in a strangely mechanised and standardised, homogenous environment. I feel this most keenly in highly civilised America, and especially in New York.

Psychological and physical frictions abound in the rifts between human beings and the enigmatic, civilised jungle they inhabit. I am deeply interested in trying to understand the relationships between people, society, and nature; and my work is forged from accumulations of these frictions.

Part 2

—

Before Leaving Home

—

Awakening as an Artist

—

1929/1957

Violet Voices

I was twenty-seven when I went to the United States. If I had not made it to the USA, I do not think I would be who I am today. The environment I grew up in was exceedingly conservative, and escaping it at the earliest possible moment had been my dream, and my struggle. I would have preferred to leave much earlier but was delayed because of the difficulty of travelling overseas in those days and the fierce opposition of my family – in particular my mother.

Still, I made it, and I am glad I did. If I had stayed in Japan, I would never have grown as I have, either as an artist or as a human being. America is really the country that raised me, and I owe what I have become to her.

I was born on 22 March 1929, in Matsumoto City, Nagano Prefecture, the youngest child of Kamon and Shigeru Kusama. My family was an old one, of high social standing, having for the past century or so managed wholesale seed nurseries on vast tracts of land. Each day a crowd of workers came to collect the seeds of violets or zinnias or whatever it might be, for resale all over Japan. We had six large hothouses, which were so rare in those days that sometimes groups of schoolchildren came on field trips to look at them. Propertied and wealthy, my family supported local painters and had a standard understanding of art. But the prospect of their youngest child becoming a painter was a different matter altogether.

My grandfather was an ambitious man, active in both business and politics, and my mother had inherited his blood and his fiery temperament. My father married into the family and adopted the Kusama name. The tension and pressure that arose from that arrangement was certainly responsible to a large degree for the oppressive atmosphere that dominated my infancy and childhood.

I entered Kamata Elementary School in 1935. By 1941, the year I matriculated at Matsumoto First Girls' High School, the war that had been going on for so long had ignited into the Second World War. And

—

it was from about that time that I began to experience regular visual and aural hallucinations – seeing auras around objects, or hearing the speech of plants and animals.

From a very young age I used to carry my sketchbook down to the seed-harvesting grounds. I would sit among beds of violets, lost in thought. One day I suddenly looked up to find that each and every violet had its own individual, human-like facial expression, and to my astonishment they were all talking to me. The voices quickly grew in number and volume, until the sound of them hurt my ears. I had thought that only human beings could speak, so I was surprised that the violets were using words to communicate. They were all like little human faces looking at me. I was so terrified that my legs began shaking.

I struggled to my feet and ran as fast as I could, all the way back to the house. I was almost there when our dog took up chase, barking at me – in human words. Astonished, I tried to say something, but now my voice was a dog's voice. I dashed inside the house in a state of panic, thinking: What's going on? What's happening to me? Pale and trembling, I wriggled into a cupboard and closed the door, and only then was I able to breathe. Sitting there in the dark, thinking back over what had just happened, I could not tell if it had been real or just some sort of dream.

At other times I would be walking a path through the fields at nightfall, the sky getting darker and darker. I would look up to see a burst of radiance along the jagged, mountainous skyline, and suddenly things would be flashing and glittering all around me. So many different images leaped into my eyes that I was left dazzled and dumbfounded.

Whenever things like this happened, I would hurry back home and draw what I had just seen in my sketchbook, churning out one sketch after another. At such times, I was not here. I was in a separate world, and I was drawing in order to document the sights I saw there. I had several notebooks full of these hallucinations. Recording them helped to ease the shock and fear of the episodes. That is the origin of my pictures.

All I did every day was draw. Images rose up one after another, so fast that I had difficulty capturing them all. And it is the same today, after more than sixty years of drawing and painting. My main intention has always been to record the images before they vanish. Take, for example, my oldest work, *The Parting,* which I made when I was very sad about being separated from a certain person. In the cupboard I found a piece of material that matched my feelings, and I clung to it and dried my tears with it before using it as my canvas. This was before I had ever

—

—

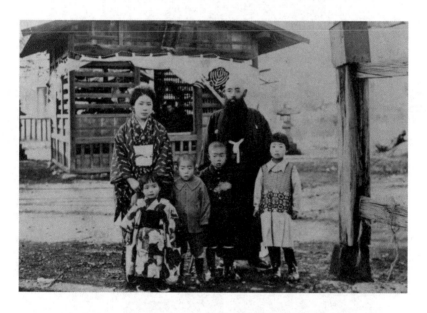

(from left to right)
**Mother, me, second brother,
elder brother, grandfather and
eldest sister at a village shrine
in Matsumoto city**
Nagano
C.1932

—

About eight years old
C.1937

VIOLET OBSESSION

—

One day suddenly my voice
became the voice of a violet
Stilling my heart Stopping my breath
You're for real, aren't you?
All you little things who
happened today

The violets on the tablecloth break free
and crawl over my body
One by one they stick to me
Sumire flowers, violets
have come to steal my love

The danger is growing, isn't it?
Just standing there inside the fragrance
Look – even on the ceiling and pillars

violets adhere
Youth is hard to hold on to
O Violets, little flowers – don't talk to me
Give me back the voice that became a violet's voice
I don't want to be an adult – not yet
All I ask is one more year
Please let me be till then

—

even heard the words 'collage' or 'assemblage'.

From my very earliest memories I have felt imprisoned by the walls of my eyes and ears and heart, upon which have been emblazoned all manner of things – nature, the universe, people and blood and flowers – in the form of wondrous, horrifying, or mysterious events. The sinister but nameless somethings that are forever peering out of the shadows of the spirit have for long years driven me half mad, pursuing me with an obsessive and almost vengeful tenacity.

The only way for me to elude these furtive apparitions is to recreate them visually with paint, pen, or pencil in an attempt to decipher what they are; to gain control over them by remembering and drawing each one that flashes through the haze, sinks to the bottom of the sea, stirs my blood, or incites destructive rage.

Psychiatry was not as accepted in my youth as it is now, and I had to struggle on my own with the anxiety, to say nothing of the visions and hallucinations that at times overwhelmed me. I feared exposure of my secret – that I had lost some of my hearing. The childhood asthma I suffered was triggered by friction between my self and the external world. There was no one with whom I could discuss these issues. The question of man–woman relations was taboo, the world of adults was wrapped in enigmas, and I felt completely cut off from my parents and society: all of this was infuriatingly unfair and – literally – maddening.

It was as if I had already given up hope for myself and my surroundings from the time I was in my mother's womb. Painting was a fever born of desperation, the only way for me to go on living in this world. You might therefore say that my painting originated in a primal, intuitive way that had little to do with the notion of 'art'.

Back and Forth between Reality and Illusion

I communed and conversed with the souls of violets and many other things. In doing so, I tumbled from the realm of reality into scintillating illusion. At such times I would break out in goose bumps, and my legs would shake uncontrollably. I would sense to my horror that this was not an illusion but reality. Deranged, I was dragged body and soul into unexplored worlds.

It was as if, beneath the duckweed at the edge of a dark and eerily silent pond, a shadowy figure beckoned to my soul. Again and again my soul was sucked down into the depths; I even have a dream-like memory of actually slipping into the pond and nearly drowning. Was it simply the hush of the instant when soul separates from body? My life has been a series of bewilderments in space and time that have sent me obsessively wandering the border between life and death.

One day, after gazing at a pattern of red flowers on the tablecloth, I looked up to see that the ceiling, the windows, and the columns seemed to be plastered with the same red floral pattern. I saw the entire room, my entire body, and the entire universe covered with red flowers, and in that instant my soul was obliterated and I was restored, returned to infinity, to eternal time and absolute space. This was not an illusion but reality itself. I was shocked to the depths of my soul. And my body was caught in that terrifying infinity net. Feeling that unless I escaped, I would lose my life to the curse of the red flowers, I ran frantically upstairs. When I looked down, the steps were falling apart behind me. I lost my footing and fell, spraining my ankle.

Dissolution and accumulation; propagation and separation; particulate obliteration and unseen reverberations from the universe – these were to become the foundations of my art, and they were already taking shape at this time.

I was also tormented by a thin, silk-like curtain of indeterminate grey that would fall between me and my surroundings. On days when this curtain descended, other people looked tiny, as if they had receded

into the distance, and when I tried to converse with them I could not understand what they were saying. If I ventured outside, I would forget the way home and wander the streets or take refuge under the eaves of someone's house, crouching in the dark all night long before remembering how to get home. This happened repeatedly. My only recourse as a prisoner of this curtain, one who had lost all sense of time or speed and was incapable even of conversation, was to lock myself in my room. As a result, I came to be seen as an even more unmanageable, 'useless' child.

Whenever I found myself slipping back and forth between this world and the unknown realms, I became ill and a slave to the act of creation. I painted pictures on paper or canvas and made mysterious, unrecognisable objects, steadily summoning up places in my own heart and re-creating them, again and again. Such experiences were a far cry from the business of made-to-order art or the pretentious, chameleonic productions of those who chase after the latest trends. My work was based upon the irrepressible outpouring of what was already inside me.

Both a gifted child and a 'bad girl', burdened with layer upon layer of problems, I was thrust into the midst of raging storms from infancy on: the protracted gloom of the never-ending war, the constant bickering of my mother and father.

My father, who had married into the family, was also from a wealthy background, and his extravagant and incorrigible profligacy was the cause of much of my suffering. He had always been a spendthrift, and his excesses included frequenting houses of prostitution and geisha quarters, and even seducing our housemaids one after another. My mother, the proud daughter of the head of the family and owner of a ferocious, implacable temper, was perpetually angry with him and kept the house in constant turmoil.

Whenever my father left for a tryst with one of his mistresses, my mother would order me to follow him and report back. I had no choice but reluctantly to do as she commanded. I tailed him even on freezing winter days, sniffling and shivering; but I was just a child, and he always managed to give me the slip. When I returned home and reported as much, my mother would vent all her rage on me. And yet she would send me out again the next time, promising a mere bowl of wonton soup as my reward, and off I would go. This sort of thing happened frequently, and it made for an atmosphere in the home that was scarcely conducive to studying.

In the midst of such a toxic family mix, the only thing I lived for was my artwork. And because I lacked all common sense when it came to dealing with society and people, the friction with my surroundings

grew ever more severe. The mental pressure and anxiety naturally increased in proportion to the criticism directed at me, and the future began to look dark and loathsome. It was as if I were stirring the same pot of shit day after day, with bare hands. A continual layering of woes gradually turned my heart into something savage and desolate.

According to the conventional wisdom of the time, a woman had no future as a painter. This 'wisdom' held particular sway in an old-fashioned and feudal family like mine, which still clung to the ancient notion that actors and painters were disreputable at best. My mother was especially vehement in her opposition to my painting. Perhaps she imagined me growing old, ill, and homeless, and hanging myself. In those days the majority of painters in the countryside were people who led hopeless lives, cadging money from the rich in order to drink. My mother was sometimes pressured into buying pictures from such people and must have thought what a tragedy it would be if her own daughter were to end up like them. She used to tell me that if I liked pictures so much I could be a collector, but that my becoming a painter myself was absolutely out of the question. Yet I sketched and painted constantly, and that made her so furious that she once kicked my palette across the room. Sometimes we even grappled physically.

My mother thought nothing of buying me any number of dresses or kimonos, but she refused to pay for paints or canvas. My father, on the other hand, was never bothered by my painting, and in fact he was the first ever to buy me art supplies. He himself was fond of drawing and got me an excellent set of paints and brushes, though my mother berated him for doing such a foolish thing. That is when I decided which parent I would go with if they ever divorced.

Born with that hair-trigger temper, my mother also had a tendency to hysteria that was only exacerbated by my father's flamboyant womanising. Sometimes when she found me painting she would overturn the desk or rip up the pictures and throw them away. Inwardly I was always at war with her. I remember one lonely dawn when, unable to bear it any longer and desperate to get away from that house, I met up with a girlfriend and we fled all the way to Tokyo.

But no matter what happened, I went on drawing and painting, piling up a tremendous number of works in stacks that spiralled to the ceiling. Images poured from my mind the way lava flows from an erupting volcano, with the result that I was forever short of canvas and paper and paints and constantly scrambling about, trying to gather supplies. And I was prepared to take any measures necessary to get them.

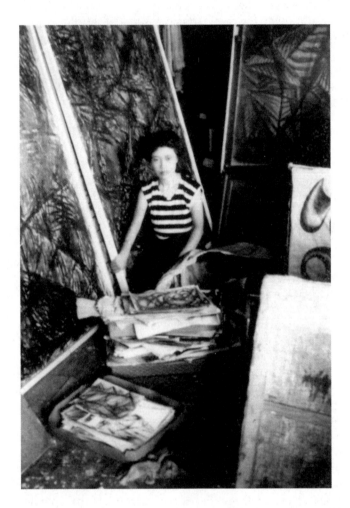

In my studio at my parents' home
Matsumoto
1950–2

I stole things that could be used as canvases, and was thrilled by my secret crimes. I even stole paint from handymen who came to work on the house. Any time I managed to buy canvas with money stolen from home, or happened to be given a set of imported oil paints by a friend, I rejoiced as if I had chanced upon a great treasure. On one occasion I tacked both halves of a large jute bag I had found to discarded window frames, and painted on them. These paintings still survive: *Accumulation of the Corpses (Prisoner Surrounded by the Curtain of Depersonalisation)* and *Earth of Accumulation.*

My mother continued to oppose my becoming a painter, however, and encouraged me to marry into a wealthy family. Photographs of prospective grooms were proffered to both my elder sister and me. After my sister settled on one and married him, the photos kept coming, and I was even asked to consider some of the suitors she had rejected. The eldest son of the director of a hospital, the son of a big landowner, and so forth – some of the most eligible bachelors in that part of the country. But I, of course, wanted only to become a painter and turned them all down.

Face to Face with a Pumpkin

In 1948, three years after the war had ended, I entered a four-year course of study at the Kyoto Municipal School of Arts and Crafts. I wanted to get away from my parents and life in that house. My mother was at last persuaded, after much discussion and argument, that it would be all right for me to leave home as long as I was attending school, and that Kyoto would be the best place for me to learn proper comportment. She arranged for me to stay in a house where the punctilious Ogasawara school of etiquette was strictly adhered to.

I signed up for the *Nihonga* or Japanese-style painting course but found it unbearable. To me, the teachers were useless, insisting only that we paint with minute precision. Exasperated, I rarely attended school but stayed in my room, working on my own. Eventually I started getting phone calls to the effect that if I continued to skip classes I would be expelled.

I hated the oppressive, hierarchical arrangement of the art world in Kyoto and the ubiquitous master–disciple system. It was all so old-fashioned and hidebound, and it sickened me to see it in action. Such relationships provided nothing but restrictions and chains, and they had a tight grip on the school itself. I found this stifling and began pining for the vast open spaces of America.

During my time in Kyoto I diligently painted pumpkins, which in later years would become an important theme in my art. The first time I ever saw a pumpkin was when I was in elementary school and went with my grandfather to visit a big seed-harvesting ground. Here and there along a path between fields of zinnias, periwinkles, and nasturtiums I caught glimpses of the yellow flowers and baby fruit of pumpkin vines. I stopped to lean in for a closer look, and there it was: a pumpkin the size of a man's head. I parted a row of zinnias and reached in to pluck the pumpkin from its vine. It immediately began speaking to me in a most animated manner. It was still moist with dew, indescribably appealing, and tender to the touch.

'Pumpkin head' was an epithet used to disparage ugly, ignorant men, and the phrase 'Put eyes and a nose on a pumpkin' evoked a pudgy and unattractive woman. It seems that pumpkins do not inspire much respect. But I was enchanted by their charming and winsome form. What appealed to me most was the pumpkin's generous unpretentiousness. That and its solid spiritual balance.

I was still in my teens – seventeen or eighteen, I believe – when my home prefecture held an exhibition for local artists. I submitted a picture of pumpkins of various sizes, painted with *Nihonga* materials – mineral pigments painted on paper or silk – and it was well received and won a prize.

I lived for about two years in Kyoto, in the mountainside home of a haiku poet and his wife and two children. My room was on the upper floor, and that is where I painted relentlessly realistic pictures of pumpkins. Before dawn I would spread a sheet of vellum paper on top of the red carpet, line up my brushes, and then sit in Zen meditation. When the sun came up over Mount Higashiyama, I would confront the spirit of the pumpkin, forgetting everything else and concentrating my mind entirely upon the form before me. Just as Bodhidharma spent ten years facing a stone wall, I spent as much as a month facing a single pumpkin. I regretted even having to take time to sleep.

Morning, noon, and night, I scrupulously painted each tiny bump on the rinds of my subjects. I painted other, similar subjects at this time as well – three green tomatoes just beginning to turn red, or a pair of yams, detailing every bruise and bristle. Perhaps best of all were my paintings of onions. I still have one of these, which constituted my graduation project. I gave it to my father, who treasured it and hung it in his room, so that it survived my move to the USA. Since his death it has hung in my own room.

In 1950, my large *Nihonga* painting *Cat* was selected for the *First Nagano Prefectural Exhibition*. In the next year, 1951, another large-scale *Nihonga* piece, *Lingering Dream*, was selected for the *Second Creative Arts Exhibition*. And then, in 1952, when I was twenty-three, I finally had my first solo show. In preparation for this, I worked day after day on watercolours, gouaches, and oils. Many of the works had infinity net motifs.

The venue was the First Community Centre in Matsumoto, and the exhibition opened in March with some 270 works, including *Death of Moths, Eternal Land, Debris of Plants,* and *Spirit of Trees.* I knew this was only the initial step in a long journey, but I felt a definite sense of accomplishment.

—

One of my first mentions in the national media came in a panel discussion on recent exhibitions in *Atelier* magazine:

> *I also went to Matsumoto City, where I saw a solo show by a young woman named Yayoi Kusama. There were well over two hundred works exhibited, and in all of them I sensed the makings of a very powerful talent. With quick black lines, what you might call a vision of the heart seems to pour forth in a free-flowing way that is really quite spectacular.*
> (*Atelier*, January 1953)

There was no time to rest between this and my second solo show, at the same venue, in October. This time there were 280 pieces, mostly oil paintings and sketches, such as *Self-Portrait*, *The Parting*, and *Sea Bottom*. The famous poet and critic Shuzo Takiguchi wrote a statement for this show.

At the opening of this second show something happened that was to prove extremely important in my life. Dr Shiho Nishimaru, Professor of Psychiatry at Shinshu University in Matsumoto, who had been treating my illness, saw my pictures and declared me 'a genius'. This led to my works being presented at a national psychiatric conference and becoming more widely known.

Dr Nishimura also encouraged me to get away from my mother: 'If you remain in that house, your neurosis will only worsen.' So I began to think even more seriously about going overseas. I knew that no matter where I went in Japan, my mother would track me down, and I did not want to end up in some sort of school for the mentally ill. But most importantly, I felt that my art stood in opposition to the conservatism and insularity of Japan. I had to get out.

—

Choosing Tokyo
over Paris

I wanted to go to Paris, and in 1953, when I was twenty-four, I was accepted by the Académie de la Grande Chaumière. Dr Nishimaru and Dr Uchimura had recommended me for a Ministry of Education scholarship, and articles were published in two local newspapers about my going to study in Europe. But then, suddenly, the opportunity arose to put on a solo exhibition in Tokyo, and I decided to cancel the trip to Paris.

In February 1954 my third solo exhibition, and first in Tokyo, opened at the Shirokiya Department Store in Nihombashi. I exhibited about eighty works, including *Seasonal Wind*, *Digitalis in the Night*, and *Ancient Ceremony*. The critics Shuzo Takiguchi, Ryuzaburo Shikiba, and Takachiyo Uemura contributed statements for the brochure.

The painter Masao Tsuruoka reviewed the exhibition in an issue of the magazine *Mizue*, which featured my work *The Bud* on its cover:

> *Microcosmic worlds unfold upon surfaces whose texture is such that one wonders how they were painted. The qualities of the paper are put to effective use in combination with tiny particles of paint in a vast range of hues, from muddy tones to high-saturation primary colours, combining materials such as gouache, watercolour, mineral pigment, enamel, ink, and varnish. The artist apparently applies these with various implements – paintbrushes, calligraphy brushes, pen, fingers. There is, overall, no fixed structural form, but a structural freedom comprising points and lines and gradations which create a harmony that embodies dissonance.*
> (Masao Tsuruoka, *Mizue*, May 1954)

In August of the same year I held another solo show at the Mimatsu Bookstore Gallery in Tokyo. The exhibition consisted of some eighty works in watercolour, pastel, and pastel crayon, including *Castle*, *Hermit*, *Sunken Meteorite on the Seabed*, and *The Heart*. In October

I contributed three watercolours to the *Eight Japanese Women Artists* exhibition at the Yokodo Gallery.

In January 1955 at the Bridgestone Museum I previewed my contribution to the International Watercolour Exhibition, which was to open later that year at the Brooklyn Museum in New York. That same month I also held a solo exhibition organised by Shuzo Takiguchi at the Takemiya Gallery. Mr Takiguchi selected about forty works, including *Octopus, God of Trees, Farmer-Turned-God, Day of Betrayal, Encounter, Sign, The Moon Dropping Out of the Colour Red, Flight of Bones*, and *Rock's Early Life*.

The author Fumiko Hayashi introduced me to the Kyuryudo Gallery in Tokyo, and in March that year I held an exhibition of fifteen works there, including *Sea Fire, God of Trees, Coral Reef*, and *Flower Spirit*. The novelist Yasunari Kawabata and the art critic Teijiro Kubo both visited the exhibition and purchased works, and Kenjiro Okamoto wrote a review titled 'A Promising Newcomer: Yayoi Kusama':

> *She combines various techniques from Cubism and Surrealism, such as decalcomania and frottage, and makes them her own, getting unforeseen results from such juxtapositions. Her work has no connection to the doctrines of Cubism or Surrealism but seems to operate directly through the senses, linking technique to physiology without conflict or contradiction. It's a very feminine painterly sensibility, and the works done some years ago with traditional Japanese materials are masterfully evocative.*
> (Kenjiro Okamoto, *Geijutsu Shincho*, May 1955)

In the same issue of this magazine, I published a 'New Artist's Statement':

> *I sing within one part of the living shadow covering the earth, within one constant manifestation of its whole. Just as concealment reveals everything, or as the little hole in the peach reveals the existence of the worm, so by a similar method I want to lay bare the mystery. I want to live hidden in the world that lies midway between mystery and symbol.*

In this essay I was critical about the socialist realism and existentialism and so on prevalent in Japan at the time. But perhaps this was only to be expected from someone who aspires to 'the world that lies midway between mystery and symbol'.

—

To quote another excerpt:

> *I intend to keep on working until the Devil backs down. Why? Because the Devil is the enemy of art and even more so its ally ... In other words, the Devil can live only in the midst of freedom. He soon flees anything settled or predetermined.*

Of course, even now – all the more so, in fact, with the passage of time – I continue to do battle with that great enemy and greater ally of art. I have never put myself into any sort of mould, and I have lived only in the realm of freedom.

—

Corresponding with O'Keeffe

In May I contributed three works – *Trick Rider's Dream*, *Elephant*, and *Stamen's Sorrow* – to the *International Watercolor Exhibition: Eighteenth Biennial* at the Brooklyn Museum in New York. These works received high praise from Kenneth Callahan, a renowned artist and one of the so-called Mystic Painters of the Pacific Northwest. Later, Callahan would introduce my work to Zoe Dusanne, the owner of the gallery in Seattle where I was to hold my first solo exhibition outside Japan.

It was not long after the Brooklyn biennial that I began corrsponding with Georgia O'Keeffe, (see p.14 above). I sent her two letters and some watercolours. In my letter of 15 November 1955 I wrote:

> *I am a Japanese female painter and have been working on painting for thirteen years since thirteen years old ... Though I feel so I am very far away from where you are and only on the first step of long difficult life of painter. I should like to ask you would kindly show me the way to approach this life.*

With this first letter I sent fourteen watercolors, including *Nostalgia of the Orient*, *Glorious Sunset at Sea*, *Distressed Stars on Earth*, *Deep Sorrow*, *Kingdom of Ferns*, *Abandoned Heart*, and *Rye and Rainbow.*

To my astonishment, I received a reply from O'Keeffe, dated 14 December:

> *In this country the Artist has a hard time to make a living. I wonder if it is that way in Japan. I have been very interested in the Art of your country and sometimes think of going there but it is very far away. It has been pleasant to hear from you.*

—

I was amazed that a person of her stature would respond in such a kind and heartfelt manner to a young person she did not know, from a country so far away. But I was even more amazed to learn that she had actually shown the watercolours I had sent her to art dealers. One of these was Martha Jackson, the owner of the number one gallery in New York at that time. Jackson, however, dealt strictly in Action Painting, and because my work was of a completely different type, she declined to buy any of them. Edith Halpert, however, did purchase one.

It turned out that all the other watercolours were lost when they were sent back to me in Japan and the ship they were on sank. I only learned this many years later, when the Center for International Contemporary Art investigated and found the records at the Georgia O'Keeffe Foundation.

I had lost works before. The first time was not because of an accident or an act of God, however, but by my own free will. As soon as it was officially decided that I was to go to America, I took an axe to hundreds of works – many as large as four feet by five – and made a bonfire of the pieces in the stony river bed behind our house. I did not want to leave those paintings and drawings behind for my mother to give away; but more importantly, I was determined to create better works when I got to New York. I burned them all with no regrets. Given what my early works now sell for, though, I was sending hundreds of millions of yen up in smoke.

At last, in January 1956, through the kind offices of Kenneth Callahan and George Tsutakawa, the Zoe Dusanne Gallery in Seattle agreed to host my first American solo exhibition. That was when I began in all seriousness to prepare to go to the USA.

Before leaving Japan in 1957, I wrote another letter to O'Keeffe, again asking for help:

> I hope with all my heart that I will be able to show my paintings to dealers in New York. I am well aware that this is hardly possible for such an inexperienced painter like me to have a chance to show the works. I know also that I am very optimistic in this regard that I seek such a chance. I have been aiming for some years that my paintings be criticized at New York. But to my regret I know nothing about the art world in New York and if I am to realize that without seeking somebody's kind advice and help I will never be able to reach New York ... You may be very embarrassed to hear my too frank words but I respect you the most.

—

—

In O'Keeffe's thoughtful reply, dated 18 August, she advised me in the gentlest tones, showing consideration for my youthful artistic ambitions:

> *You seem to be having a hard time to get here. If you do get here I hope it will seem to be worth your trouble. When you get to New York take your pictures under your arm and show them to anyone you think may be interested. You will just have to find your way as best you can.*
>
> *It seems to me very odd that you are so ambitious to show your paintings here, but I wish the best for you.*

I can understand how my determination to leave Japan and go to New York might have seemed odd to her. But this resolve was intimately connected with the fundamental question of why I continued creating art.

—

As Soul Separates
from Body

Born into a hopeless situation with parents who did not get along; growing up tossed about by the daily storms that raged between mother and father; tormented by obsessive anxiety and fears that led to visual and auditory hallucinations; asthma, and then arrhythmia, tachycardia, and the illusion of 'alternate bouts of high and low blood pressure' and 'blood seeming to flood the brain one day and drain from it the next': such eruptions of mental and nervous disorder, wrung from the scars left on my heart during the hopeless darkness of my adolescence, are fundamentally what keep me creating art.

The focus of the mental and nervous ailments afflicting me is a condition labelled 'depersonalisation'. I feel as if I am in a place where pleated, striped curtains completely enclose me, and finally my soul separates from my body. Once that happens, I can take hold of a flower in the garden, for example, without being able to feel it. Walking, it is as if I am on a cloud; I have no sense of my body as something real.

In the midst of that fuzzy state when the soul seems to have separated, all sense of time is lost. A second can seem like many hours. At that point, all I can do is stand there, staring into space, or curl up in a ball.

'Depersonalisation' refers to the phenomenon of experiencing a loss of personality. I am told that when reality is too agonising, human biology has ways to turn it off, and that this innate defense system is what triggers the condition. But the horrible suffering of depersonalisation is much greater than the pain of any reality: a hellish reality is still better than the experience of losing yourself, the world, and time. It is terrible seeing existence annihilated. At least in reality you get a solid sense of the self that is suffering.

—

THE GOBLINS ARRHYTHMIA
AND TACHYCARDIA
—

Arrhythmia eerie waves suddenly
throwing the blood of the whole body out of whack
I always hear muffled Hell's
hideous groans What sound is that?
Always this same voice Battling arrhythmia
Grappling Pushed over the precipice
Making the blood flow backwards Hot tachycardia
all but erupts through my crown
In the midst of it the shock of anxiety
My heart dropping, dropping
upside down into the orderly sea of delusion
Hallucinations of blood Drowning
Arrhythmia doesn't play fair Tachycardia is a sea of fire
How many years of days from childhood on
have you two assaulted me?
I need to know what made
you goblins ruin
the days of my life so carelessly

If I had known before I was born
it was this sort of chess game
why would I ever have accepted birth?
I'd like to give it all back

—

Push it all right back in the womb Hatred
All you torments waiting on the long road ahead
The birth I had no choice in
The adults must have slipped up in sex
I an uninvited guest in this world
have no wisdom to offer nothing splendid like that
For me it's just
a nuisance having been born

Dead and departed Father
I wanted you to take this anxiety of the blood with you
to the Underworld
Goblins I don't want to climb
the steep road of life that lies ahead
bearing this bottomless anxiety

In the blood the unending fear
after the rush of hallucination
Try as you might to heal this with
care and love the vast
disorienting ocean reaches to the depths of beyond
I don't know how to swim to the far shore and live

—

PRISONER SURROUNDED BY THE CURTAIN
OF DEPERSONALISATION

—

I won't chase it far the retreating scenery
Let it go Let it disintegrate
Open the striped curtain Melancholy outing Chest hair
torn out Poor red-earth gooseflesh Clutch it in one hand
Rub it against the wounded hole Night falls
Part the dusk Slip back inside the curtain
Desolation flutters and scatters across the sky
My disoriented heart inside and outside the curtain
Anxiety with rough hands strips away skin

Heavy like a drop curtain Painful like chest hair
Shadows White Into the dark Bird-balloon buoyant
Tracks of tears entwine forlornly
dampening crevices in tender skin
If you shake off today and stand depersonalised
they come back Last year's footprints The way it felt
Pain itself tossed to the skies I
grow wild wings I want to return to the earth
Hometown bathed in Light I want to return to the earth
Open the shape called Love I want to return to the earth
Escape the curtain's prison I want to return to the earth
Don't hurt your chest hair, boys I want to return to the earth
Turn your ruined tomb into the orphan sky of anger
Looking for what? When looking up
Calling to one corner of empty space
Why? Why? Why?
Tomorrow sitting on the terrace recedes in the distance
Evening walking down the road trees float on the earth
Stop a moment and the town recoils
Be gone Go fall apart Get broken
Vision unhinged weary of the sudden visitation
seizing the body on Kagurazaka Hill Emptiness
pouncing The powerful arresting hand
receding in the distance The noise of the crowd
going away Tangible on all sides The weight
Fearing clairvoyance The blind spot distorted
Losing it The texture of the horizon

—

Milky white and ash gray and black blue of the sky
Dripping sweat The world shaken
Movement in the earth's crust Mountain slopes collapse
covering up the city of foolish illusion Great nature's
dirt falls on my angry hair
Mountain stream swollen White heat of red begonias
Sun on fields Disappearing deep primula crimson
If you fall in the mountain stream dried twigs of iceplant
Kneescrape on boulder's edge and shiver of spiderwort
If you reach your home town
decayed thorns of the rose
balsam zinnia Chinese aster tears
Grind them to powder to burn on a rock
I stir the ashes of fragile flowers
and then again the recurring
ashes of fragile flowers the recurring
depersonalisation Forgetfully leaving myself inside
Evening falls in solitude Scary stuff
Endless limited life Sea of bitterness
Debris dust whisked away fluttering
Ah I have managed to use up most of a lifetime
Weariness of flesh and blood fading
turning the hair to withered gray
more fragile than burned flowers' ashes Wrapped
in milky whiteness inside the gray curtain Now
all things in creation flee drawn
to individual gravity
So strong Calling out from the world of the dead
If you stand in the silent connection
the disappearing body rustles heaven's curtain
and parts it So simple
Nothing to it It just
crumbles and disperses
The sky blue tomorrow too and soft
After the nothingness when I'm gone
After tens of billions of light years it will still
be there

—

To a Freer,
Wider World

I fight pain, anxiety, and fear every day, and the only method I have found that relieves my illness is to keep creating art. I followed the thread of art and somehow discovered a path that would allow me to live. If I had not found that path, I am sure I would have committed suicide early on, unable to bear the situation in which I found myself. I remember the many times I stood beside the tracks of the Chuo Line, waiting for the train and thinking of ending my life. What saved me was making my way – blindly and gropingly at first – down the path to art.

If I wanted to develop and widen that path, staying in Japan was out of the question. My parents, the house, the land, the shackles, the conventions, the prejudice.... For art like mine – art that does battle at the boundary between life and death, questioning what we are and what it means to live and die – this country was too small, too servile, too feudalistic, and too scornful of women. My art needed a more unlimited freedom, and a wider world.

I was set to leave for the USA on 11 November 1957. The mayor of Matsumoto City hosted a big farewell party for me, and on the day of my departure a large crowd came to Matsumoto Station to see me off. But by then my heart had already flown to America.

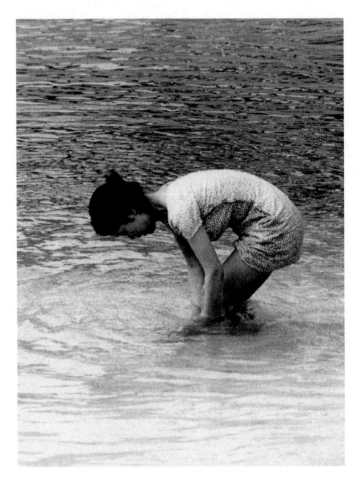

In New York
1959

SORROW LIKE THIS

—

So downhearted
not even autumn leaves in the Shinano sun
can console me
How long has my heart grieved?
Thinking back it must have started at birth
What was I in a previous life?
This morning dark-hearted I thought of hanging myself
This evening of throwing myself in front of a train
I saw the tracks floating through the fields black in the dusk
I walked upon them back and forth
No love Empty life No hope
Thinking only of extinction
Racking my brains searching for a place to die
Ahh so tired like a beggar
bent over the gutter vomiting
hair white and frayed back hunched
desperately turning a blind eye to the approaching shadow
Come, Death, if you're coming Let me embark for the universe

—

Part 3

–

No More War: The Queen of Peace

–

Avant-garde
Performance Art
for the People

–

1967 / 1974

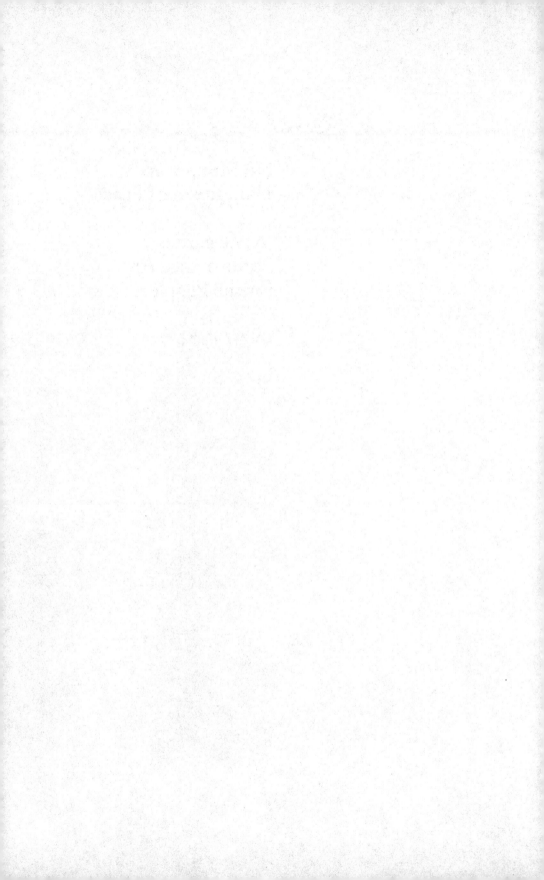

In the Hippie
Whirlwind

By 1967 I had already been in America for ten years. During that decade I had developed not only as painter but as an environmental sculptor. I had achieved many successes, and the name Yayoi Kusama had gained notoriety in the avant-garde of America – and, indeed, of the world. Yet Japan alone remained closed to me.

I continued to change and develop in major ways. I was becoming an artist not just limited to fine art, but one who was able to express herself in a wider spectrum of activities. It all came together with the Happenings. I had experimented with performance art as early as 1965, but in 1967 I began staging one Happening after another.

It was at about this time that the hippie movement was taking shape in Greenwich Village and beginning to stir up quite a little whirlwind. The hippies' social customs, ideas, and actions were very avant-garde and seemed to foretell the shape of things to come. Like the beatniks before them, hippies were groups of young people who were in rebellion against America's mechanised and increasingly computerised culture, and wanted to reclaim their alienated humanity.

At first there were only a few small clusters of hippies. But by 1967 they had clearly become a powerful movement, with their call to 'return to nature' making its way into mass culture and then, more directly, into sexual mores.

Girls, freed by the pill from having to worry about pregnancy, asserted their humanity by participating in the wildest and most primitive kinds of sex. In fact, every imaginable sort of sex was readily available in the hippie movement: homosexuality, lesbianism, sadism, masochism, whatever your pleasure.

The beatniks, hippies, gays and lesbians, and the awakening of free love, were not unrelated to my art, and my bold Happenings received overwhelming support from the young. In fact, their demand for a restoration of humanity had much in common with the themes of my work, which has always asserted itself by shocking the viewer.

Many factors – the war in Vietnam, US politics, the tragedies of the sprawling composite nation that was America – coincided to help spread the cry for a return to humanity throughout the country, day by day. Hippie fashions and arts and crafts became mainstream youth culture, and the resulting mass movement, with its opposition to the war and the draft, and support for the anti-war Senator Eugene McCarthy, actually succeeded in rattling the Establishment.

In January 1967 I produced a Happening called the *Body Paint Festival* in front of Manhattan's St Patrick's Cathedral on Fifth Avenue, one of the famous landmarks of American religion. The performers were a group of young male and female hippies. In front of a large crowd of spectators, I instructed them to remove all their clothes and burn some sixty American flags. I stood amid the smoke, tossing bibles and draft cards into the flames. Once that part of the performance was over, the naked youths embraced and kissed, and some even began having sex. It was Sunday, and a solemn mass was being observed in the cathedral. Outside, the crowd that had gathered to watch the Happening reacted with delighted squeals, mournful shrieks, and angry shouts. Some began to bellow 'It's blasphemy!' or 'Disgraceful! I can't bear to watch!' And yet they all continued to stand there, riveted by what they were seeing.

Reporters from such organisations as the Associated Press, the United Press International, and the *New York Times* gathered around me. But just as we really got rolling, more than forty policemen rushed in and brought it all to a halt.

As a result of this Happening, however, my name became known throughout the United States. Shortly afterwards, a New York-based representative of German television saw an article about the event and called me. He said he wanted to broadcast a Happening on West German TV. I accepted his offer and planned a radical and entirely original project that made use of *Love Forever*, the environmental piece I had made the previous year. This was the large mirror room with programmed, blinking coloured lights in the ceiling. For the Happening, a living sculpture writhed underneath the pulsating colours – a group having sex. I cast only men, so the sex was strictly homoerotic.

I held the event at my studio, in front of some forty journalists. The German staff switched on the bright lights and began filming. Everyone seemed to hold their breath as they watched. To those bound to traditional morality, the sight of muscular bodies entwined beneath the flashing coloured bulbs must have seemed grotesque, but even the most prim and proper amongst them ended up entranced by and drawn into that very grotesqueness.

On a soft-sculpture sofa
1968

The spectators and performers seemed to melt into one, filling the studio with an indescribable sense of rapture. There were several female journalists, and every one of them grew excited: they breathed heavily, and their eyes glistened with a peculiar light as they peered at the tangle of male bodies. Some of the men who were watching moaned audibly, and I noticed a few had undone their zippers and were busy masturbating.

On stage, as the Sex Happening was nearing its climax, the performers began whipping each other with leather belts and doing sexual things with dogs and so forth, finally painting one another with polka dots.

Polka dots were the trademark of the Kusama Happenings. The red and green and yellow dots might represent the circle of the earth, or of the sun or moon, or whatever you like. Defining them was not important. What I was asserting was that painting polka-dot patterns on a human body caused that person's self to be obliterated and returned him or her to the natural universe.

As the Kusama Happenings gained notoriety, I acquired more and more fans. Reporters would corner me and excitedly ask about the next Happening, and the crowds grew in size and enthusiasm. This, I believe, is because I was in the vanguard of providing what the times demanded.

The State of Sex
in New York

So what was the prevailing sexual atmosphere in New York City as these seeds began to grow?

The area around St Mark's Church in-the-Bowery, located in the East Village, was the birthplace of the new Underground and a magnet for beatniks and hippies. Rich men came to the area looking for sex and street kids, and there were plenty of pimps eager to supply them with 16- or 17-year-old hippie girls. White ladies came, too, looking for 'coloured' lovers, drawn by the stereotype of the sexual prowess of dark, muscular men. Blacks were still discriminated against in mainstream society, but the tendency to prize them as sexual playthings was taking root.

Meanwhile, orgies were all the rage. Sex parties were held virtually every night at the Palace Hotel, and some of these were frequented by famous Hollywood actors and actresses.

Unfortunately, such decadence and hedonism played a big part in the spread of venereal disease. At one point something like 90 per cent of those on the scene were infected with VD. People often had two to five sexual partners a night, and outbreaks spread like wildfire.

Among this crowd, the casual taking of LSD also became commonplace. My friend Richie would grab young hippies who had just arrived from out of town and tell them he had a fresh batch of LSD he would share with them for $5 a tab. The tablets contained nothing but aspirin, but Richie felt no remorse and remained indifferent, even when the victims complained in the midst of an orgy that 'That acid isn't any good – I'm not even seeing any trails!' He would shrug and tell them it must have something to do with their metabolism.

Another friend, Doug, lived in a cheap apartment with seven male friends. All of them were homosexual, and they all performed in my Happenings. They carefully divided up the $180 rent and the grocery bills, and each night they switched partners and made love to one another.

'I'm sleeping with Robert tonight.'

'All right, then. I'll go with Doug.'

They shared their bodies freely and got along perfectly well.

Homosexual actors and businessmen often visited this apartment – their goal, of course, being uninhibited gay sex.

Lesbians, too, flocked around Doug and his friends. They all got along swimmingly, since the men did not try to have sex with the women, nor did the women want them to. They were able to enjoy one another without the complication of sex or the fear of pregnancy.

'What do you think? Shall we all join forces tonight?'

'Why not? Let's get crazy!'

In a brightly lit room, men would tensely entangle with men and women with women, creating a curious festival of sex. The hot whispers of the lesbians leaked out between sighs and moans.

'How's it going over there?'

'It's the best … Fantastic…'

The male homosexual orgies were generally held on the weekends, with ten or more naked men getting it on with one another while soul music played in the background.

Most of the men around me were enthusiastic homosexuals. My assistants, my managers, my photographers – even most of the journalists who came to cover my homosexual-themed Happenings were gay.

I had a group of nude dancers we called the Kusama Dancing Team – beautiful young men aged between sixteen and twenty. I let these boys, all of whom were gay, live in my studio in the East Village. They would bring other, inexperienced young boys there to initiate them into the mysteries of sex. 'Take off your clothes and lie down,' the initiator would say gently, then proceed to stroke and kiss the initiate and play with his cute little thing. Once the level of excitement had been raised sufficiently, the ceremony gently proceeded to its climax. I do not know how many times I heard those young boys squeal. But they were always squeals of joy.

These 'made' boys often ended up living with older men. Strange as it may have seemed to some, this sort of thing became prevalent across the USA. At Columbia University, for example, the Student Homophile League was established much like any other extracurricular programme, and the university turned a blind eye to it.

Of course, not everyone in America was homosexual. Extravagant and bizarre orgies became popular among heterosexual men and women as well.

On Fifth Avenue in the heart of Manhattan, overlooking Central Park, were many of the finest hotels, including the world-famous Plaza

and the exclusive Pierre. Luxury apartment buildings in this neighborhood served as the virtual headquarters of the orgy scene. Here the elite of New York lived in suites that were on a scale unimaginable to anyone accustomed to Japanese apartments or condominiums. Gorgeous palaces with fifteen rooms were not uncommon, some with Arabian-style interiors dazzling enough to make even royalty gasp.

Many famous Hollywood stars had apartments in this area, including an actress whom I shall call 'S', who had visited Japan. 'S' was so active in the sex scene that she was labelled a 'stone freak'. She occasionally slipped unobtrusively into the orgies put on by a 'Mr K', a self-made man who had accumulated a vast fortune as president of a manufacturing company. 'S' was obsessed with a black saxophone player from a nightclub on Broadway, with whom she was wildly promiscuous. More than once I witnessed her being ravished by the musician, writhing under the weight of his muscular body and caterwauling ecstatically. And she was not the only famous white actor I witnessed moaning in the throes of interracial sexual ecstasy.

Once, a group of forty-eight members of a certain country's aristocracy who were touring the USA attended an auction at a famous gallery on Madison Avenue. I also attended, and at the party afterwards someone whispered in my ear: 'I want very much to experience a New York body-painting party. Won't you invite me?' The ladies were aloof and chaste-looking on the outside, but inwardly they were extremely curious about these things. I do not need to describe the sort of coquetry they displayed later that night.

Of course, the orgies were not only for the elite. A party I witnessed in Harlem could only be described as a masterpiece of the form. The writhing tangle of flesh and the astonishing sexual techniques were enough to leave even an observer as unshockable as myself gasping.

And then there was 'P', a reporter for one of New York's newspapers, who was known to maintain a pool of exceptionally pretty women whom he introduced to gentlemen of the elite classes. Through his work he knew a large number of famous and not-so-famous models and actresses – a tribe whose members were willing to do anything to get ahead. 'P' mediated between these women and prominent businessmen and wealthy tourists. He once boasted to me that he could assemble thirty beautiful escorts at the drop of a hat.

Being Creative with
the Naked Body

I could recount many more examples, but suffice it to say that every imaginable sex service was available in New York, catering to every taste. Most of the workforce were hippies. It was because of the fertile ground they had prepared that the Kusama Happenings blossomed and met with such fervent support, and I too surrounded myself with hippie followers.

In covering Kusama Happenings, the national media, centred in New York, described me as 'intense', 'mysterious', and 'multi-faceted'. And many of the articles written about my activities delved into speculation and rumours about my private life. Such analyses contained many misunderstandings and wildly inaccurate guesses mixed in with a few truths, and the 'Yayoi Kusama' they portrayed was someone completely unrecognisable to me. I did not think of myself as mysterious or difficult to comprehend. It is true that at each of my Happenings we broke ten or fifteen different laws, but those laws only represented the ideology of the Establishment, which was essentially irrelevant to my art.

From the Establishment point of view, public sex and flag-burning were clearly outrageous acts, and everywhere I went the police were sure to turn up. I never let that bother me, however. I had five or six lawyers advising me as I carefully walked the blurred line between art and the law. I also had a contingent of hippie bodyguards. My studio received frequent complaints and threats by phone, and my bodyguards took it upon themselves to be prepared at all times to protect me from any sudden outburst of violence.

It was partly because of this entourage that some journalists began to describe me as the 'Queen of the Hippies' and to assume that I was the sort of woman who slept with anybody and everybody. But in fact I had no interest whatsoever in drugs or lesbianism, or indeed any kind of sex. That is why I drew a line between myself and the group. They all called me 'Sister' because to them I was like a nun – but neither male nor female. I am a person who has no sex.

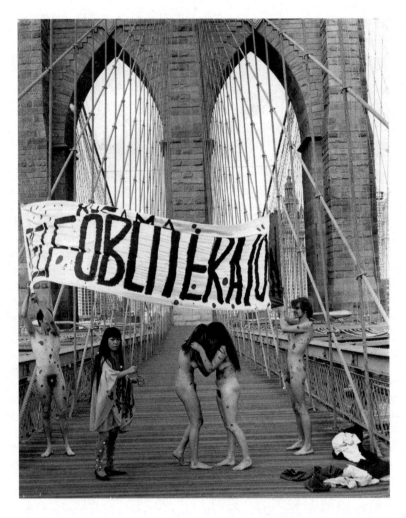

Anti-War Naked Happening
New York
1968

My aversion to sex has its source in the environment and experiences of my childhood and formative years. I hated the shape of the male sexual organ, and I was repulsed by the female organ as well. They were both objects of horror for me. As I said before, my Psychosomatic Art is about creating a new self, overcoming the things I hate or find repulsive or fear by making them over and over and over again. That is why I incited the men and women in my Happenings to strip off their clothes and submit to having their naked flesh painted. I was the creator and choreographer, but never a participant. This was how I expressed myself.

In those days my entourage had about fifteen core members, including the Kusama Dancing Team, and as many as two hundred hippie performers I could call on regularly. They would come running at any time, day or night, to join one of my Happenings. Some of them would give me their bedroom eyes and say, 'Sister, why won't you sleep with me?' Some even happily laundered my underwear. But I absolutely never had sex with any of them. If I showed a little extra kindness to one, the others would immediately gang up on him.

'This bastard's been sucking up to Sister!'

'Trying to get her all to himself!'

They'd make quite a scene, stripping the offender naked, kicking him, and lashing him with a leather whip.

I myself sometimes had to discipline the men who insisted on trying to seduce me. Cracking the whip against their white skin and seeing the red welts rise, I felt an indescribable pleasure. And some of them submitted eagerly to this punishment.

In this heady atmosphere, the gay boys closely watched the movements of any new visitors to the studio to make sure no one ever laid a hand on me.

I used these boys, and a lot of girls as well, in one performance after another. I painted polka dots on their naked bodies in Self Obliteration Happenings or Body Festivals, and as these events became the focus of controversy not only in New York but on a national scale, I became a 'Person of the Hour'. I appeared on the front page of the *Daily News* twice in one year, something not even Broadway stars managed to do.

The reason my Happenings made such regular use of naked bodies may lie in certain incidents from my childhood. I was a little girl who drew pictures all the time when indoors; but outdoors my other half emerged – a tomboy who loved to climb trees. In those days, when summer holidays came around, I would go to stay with relatives. And at night I would assemble my aunts and cousins in one corner of the

parlour and dance naked before them. I would sing – to a random melody – lyrics I had written, waving yellow fans and dancing elaborately, without a stitch on. The relations all clapped along and cheered, but as the night wore on they naturally began to nod off. I would nudge the dozers awake and badger them all to 'Watch me do just one more!'

Once word of my unclothed performances leaked out to the neighborhood boys, all I ever heard from them was: 'Let us see you dance naked!' So I enlisted a cousin to be my business manager, and we charged admission. We spread a straw mat in the garden, and there, in my birthday suit, I did impromptu dances while singing songs of my own composition. The boys who had gathered watched my performance with expressions of rapt serenity on their faces. It was then that I realised just how deeply males long for the naked female form.

A bitter memory is connected to this experience, however: when my mother found out what I had done, she beat me nearly unconscious.

All my childhood memories of Mother are of the incessant scoldings and beatings she inflicted upon me, or the way she used to put me down even in front of the maids and servants, saying things like, 'When you have four children, one of them can always turn out to be utter trash.'

And, as I have said, she was forever fighting with my father. The fights were always about him, the adopted son-in-law, spending his days and nights fooling around with geisha. Never at any time in his adult life was my father without a mistress. When I was very young he left us and ran off to Tokyo with a geisha he had redeemed from her contract. Later, when he developed lung trouble, he returned and imposed upon my mother to nurse him for ten years. As soon as he recovered, however, he began womanising again, even more energetically than before.

Relentless womanising seemed to run in the family. My father and grandfather both chased after women as if it were a competition. The menfolk were practitioners of unconditional free sex, while the women had to sit in the shadows and bear it. Even as a child I was angered and repelled by the injustice of this, and it has had a great deal of influence in shaping my thought.

My intense hatred for and fascination with the naked human body, and in particular the male and female sex organs, are almost certainly rooted in these childhood experiences.

From a very early age I loved to take clothing, paper, books, and what have you, and slice them to shreds with scissors or razors, for which my mother severely punished me. I also enjoyed smashing window panes and mirrors to smithereens with a rock or hammer. I now wonder

—

if such behavior was not simply my way of showing how I yearned for affection.

At one point I went through a phase when I enjoyed snipping off the heads of flowers. I would toss the tight blossoms into a hole I had secretly dug, until I had accumulated hundreds of them. I also drew pictures of flowers in full bloom, the petals of which formed shapes that resembled vaginas. The dots in the centres represented penises.

Whenever my mother was on the warpath, I would take refuge in the lavatory. Inside, with the latch secured, I felt safe at last and free to draw sheet after sheet of these sexual flowers. I drew vaginas that had been chewed by dogs and trampled underfoot or penises that were smeared with cat excrement; I called these pieces 'Toilet Art'.

Later, when I held a solo exhibition at the Kyuryudo Gallery in Tokyo, the author Yasunari Kawabata purchased *Sea Fire* and *Stamen's Sorrow*, phantasmal works from this noisome period of my early youth.

I am convinced that this combination of hatred and fascination for sex, which I had harboured ever since early childhood, was the motivating force that propelled me into the Kusama Happenings.

—

Body Painting
Europe

—

My Happenings first took off in New York, but soon found adherents throughout the USA and overseas as well. In October 1967 I staged a performance at the opening of a solo exhibition in Amsterdam that involved daubing the skin of naked men and women with fluorescent paints. We turned off the lights, and the disembodied colours emerged from the darkness.

As soon as we began to disrobe, the crowd reacted with catcalls and heckling. I reasoned with them, earnestly explaining that the suppression of sex was directly related to war. 'Which do you think is worse, war or free sex?' I asked. 'Do you prefer war?' The crowd instantly fell silent. I like to think that I was able to open the eyes of some of the conservative Dutch to the importance of sexual liberation. Unfortunately, however, the incumbent of the church in which the Happening took place was forced to resign.

My next Happening was at the famous Catholic Student Center in the beautiful old city of Delft. In this event, which I called *Music and Love*, I first asked the members of the orchestra to take off all their clothes, then encouraged the writers, artists, and journalists who had come to watch to get naked as well. Except for a few museum workers who managed to hang on to their uniforms all night, almost everyone ended up joining in and stripping.

What ensued was pot-smoking, go-go dancing, and general carousing until dawn. I walked through the crowd painting everyone with patterns of red, blue, and yellow polka dots. By the time the police marched in, at about five o'clock in the morning, almost everyone had retreated to their apartments for sex parties.

This Happening was shown on TV throughout Holland, and in Belgium and Germany as well. The Student Center where the Happening had been held was closed down by the police, and the naked musicians had their entertainment licenses temporarily revoked. Local avant-garde artists naturally joined me in protest against the police actions,

—

denouncing Holland as excessively conservative and demanding to know what harm there was in nudity.

Next, for a solo exhibition at a museum in Rotterdam, I staged a Happening called the *Love and Nude Body Antiwar Parade*. I stood at a church altar inside the museum and yelled, 'Let the body painting begin!' Just then, a voice in the crowd cried out, 'The cops are here!' Others shouted, 'Don't be afraid! Don't stop!' as the space became a hornet's nest. Climbing up onto the altar, I shouted, 'People of Holland! Each of us has only one life, one body. And yet throughout our history War has been forced upon us, trampling roughshod over our Love. What we are presenting to you tonight is the majesty of humanity's innate beauty. This is something that no bullets or rifles can take from us …'

We subsequently staged the same sorts of Naked Happenings in Belgium and Germany, but the result in each case was a struggle between spectators urging us on and police ordering us to stop.

I had always managed to escape being taken into police custody, but I directed so many of these performances in New York that eventually I was arrested there. While I was in the holding cell, a patrolman came by with an elevator boy – a friend of his, apparently – and said, 'Kusama, get up! My buddy here wants to shake your hand.'

A number of police officers came to look me over: 'So this is Kusama – awfully small, isn't she?' I think they were especially curious about me because I had evaded arrest so many times. But I must say that some of them were extremely kind. When I told a handsome young officer that I was hungry, he actually went out – at two o'clock in the morning – and bought me some cake and coffee.

At the time, I was widely known as Kusama the Naked Painter, and from behind the bars of other cells came voices asking if they could be part of the next body-painting event. This made it clear to the police that I was a popular figure, which meant that none of them treated me roughly.

To publicise my Happenings I had been producing leaflets and press releases bearing slogans such as:

Please the Body
50% is Illusion and 50% is Reality
Learn, Unlearn, Relearn
The Body is Art

This was the same year that I produced, starred in, and directed *Kusama's Self-Obliteration*. The film, which we shot in Woodstock, New

—

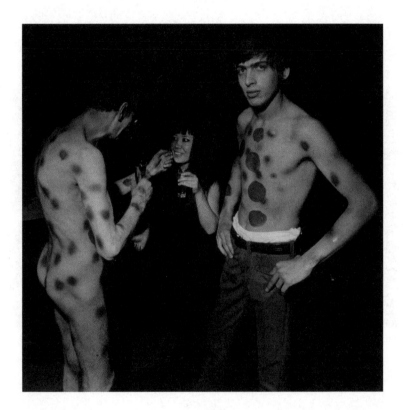

With Jan Schoonhoven (left)
Schiedam Museum,
the Netherlands
1967

—

—

Kusama's Self-Obliteration,
pamphlet for Fillmore East
New York
1968

—

York, began with me placing polka dots on a horse, a meadow, and a pond (using a brush to daub dots on the surface of the water), before shifting to a scene in the studio, where the polka dots proliferate at a Body Paint Happening.

This work won awards at the 1968 Fourth International Short Film Festival in Belgium, the Second Ann Arbor Film Festival, and the Second Maryland Film Festival, and from January 1968 it was screened (at $2 a ticket) at discotheques, gymnasiums, and outdoor venues across the USA, creating a storm of controversy.

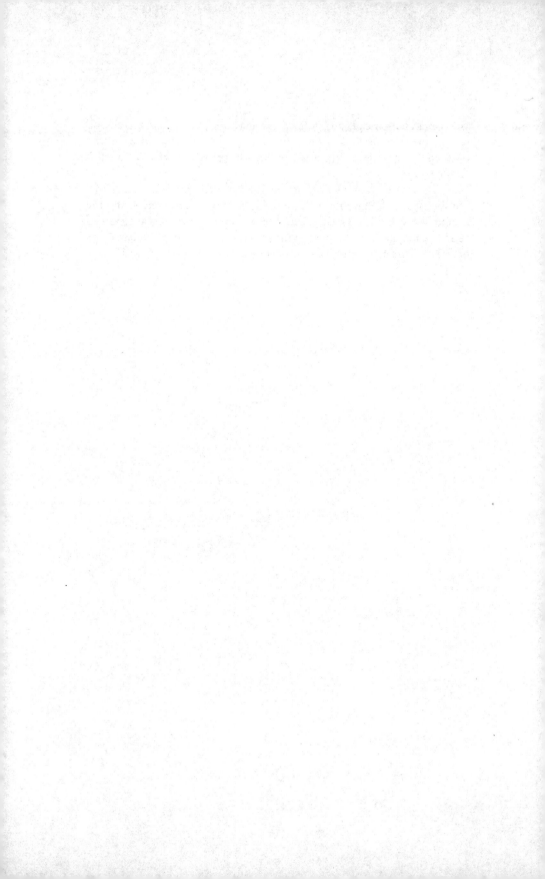

The Priestess
of Polka Dots

We rolled out even more Body Paint Happenings in 1968 than we had the year before, but by now they were not solely about art but increasingly reflected the social turmoil of the times and opposition to both the war in Vietnam and the government. In other words, the Happenings were not merely increasing in number and scale; we were expanding the scope of the genre itself, even as we refined it.

The performances of this period could be separated roughly into three categories. The first was the normal 'art' Happening. Second was what may be called the 'socio-political' Happening, a category that reflected my interest in the historic social issues of the day. This was a year of upheaval, in which a presidential election was held even as the war in Vietnam escalated and the anti-war movement exploded. The third category involved fashion and music and was to play a part in the business enterprises I would soon establish. Of course, all the Happenings contained some elements of each category.

I did not focus exclusively on Happenings during this time, but continued to hold solo exhibitions and contribute to group shows in the USA and Europe. Nevertheless, I would like to briefly describe some of the more notable Happenings among the many we staged that year.

In February, in front of a church on Wall Street, we organised an anti-war demonstration called *The Body Paint Festival*. This time I was arrested and put on trial.

Between July and November we held, at various locations, a new series of Happenings called *The Anatomic Explosion*. The first of these was across Wall Street from the New York Stock Exchange, in front of the bronze statue of George Washington. This was an anti-tax Happening and featured professional dancers. Two men and two women, completely nude and spray-painted with polka dots, danced around the statue. This event, too, ended with the arrival of the police after only a few minutes.

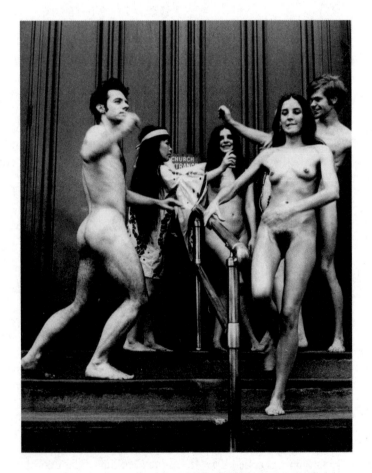

**Naked Happening in front
of church**
New York
1968

—

My manifesto for that day included the following slogans:

> NUDISM *is the one thing that doesn't cost anything.*
> CLOTHES *cost money.*
> *Forget yourself and become one with Nature. Lose*
> *yourself in the ever-advancing stream of eternity.*
> *Self-obliteration is the only way out. Kusama will cover*
> *your body with polka dots.*

The *Daily News* described this Happening in an article with this headline:

> NUDIES DANCE ON WALL ST.
> AND COPS DON'T PINCH 'EM

We also held a Happening in July in front of the Statue of Liberty. The leaflets we passed out read:

> *Liberty is all dressed up with no place to go...*
> *The true symbol of liberty is the nude.*
> *Nudism is the one thing that doesn't cost money.*
> *Clothes cost money.*
> *Property costs money.*
> *Taxes cost money.*
> *Stocks cost money.*
> *Only the dollar costs less.*
> *Let's protect the dollar by economizing.*
> *Let's tighten our belts!*
> *Let's throw away our belts!*
> *Let the pants fall where they may.*

In August we gathered in Central Park for an event that I advertised as

> *featuring me, Kusama, mad as a hatter, and my troupe of*
> *nude dancers. How about taking a trip with me out to*
> *Central Park ... under the magic mushroom of the Alice in*
> *Wonderland statue. Alice was the grandmother of Hippies.*
> *When she was low, Alice was the first to take pills to make*
> *her high.*

—

—

I, Kusama, am the modern Alice
in Wonderland.
Like Alice, who went through the looking-glass,
I, Kusama (who have lived for years in my famous, specially
built room entirely covered by mirrors), have opened up
a world of fantasy and freedom.
You too can join my adventurous dance of life.

In September we gathered in front of the United Nations
Building, where we burned fifty American flags.
In October, back on Wall Street, we held a Naked
Demonstration,
the leaflet for which bore this statement:

Stock is a fraud!
Stock means nothing to the working man.
Stock is a lot of capitalist bullshit.
We want to stop this game. The money made with this stock
is enabling the war to continue. We protest this cruel, greedy
instrument of the war establishment.
Stock must be burned!
Burn Wall Street.
Wall Street men must become farmers and fishermen.
Wall Street men must stop all of this fake "business".
Obliterate Wall Street men with Polka Dots.
Obliterate Wall Street men with Polka Dots on
their naked bodies.
Be in ... Be naked, naked, naked.

November 1968 found us in front of the New York Board
of Elections. Here I made public an 'Open Letter to My Hero,
Richard Nixon':

Our earth is like one little polka dot, among millions of other
celestial bodies, one orb full of hatred and strife amid the
peaceful, silent spheres. Let's you and I change all of that
and make this world a new Garden of Eden.
Let's forget ourselves, dearest Richard, and become
one with the Absolute, all together in the altogether. As we
soar through the heavens, we'll paint each other with polka
dots, lose our egos in timeless eternity, and finally discover

—

'Kusama Fashion'
New York
1970

the naked truth:
 You can't eradicate violence by using more violence.

Also in November, in a spacious rented loft on Walker Avenue, where we had set up the Church of Self-Obliteration, we held a Happening called the *Homosexual Wedding*. The invitations and press release announced that Kusama, 'the Priestess of Polka Dots', would conduct the ceremony, and contained a brief statement:

> *The purpose of this marriage is to bring out into the open what has hitherto been concealed ... Love can now be free, but to make it completely free, it must be liberated from all sexual frustrations imposed by society. Homosexuality is a normal physical and psychological reaction, neither to be extolled nor decried. It is the abnormal reaction of many people to homosexuality that makes homosexuality abnormal.*

The bride and groom – the two gay men getting married – wore a single wedding garment that I had designed. This 'gown for two' was the first of a great number of unisex 'natural clothing' designs I went on to create.

From Way-Out
Dresses to Musicals

In order to expand my work into a wider range of genres, in 1968 and 1969 I established a number of business enterprises. In terms of content, these could be divided into four general categories. The first was concerned with the planning and production of Happenings and included Kusama Enterprises, Kusama Polka-Dot Church, and Kusama Musical Productions.

The second category focused on clothing and fashion. The Kusama Fashion Company produced and sold Kusama dresses and textiles. I found financing to the tune of $50,000 for a factory to mass-produce my garments, which were sold in four hundred stores and boutiques across the United States. Bloomingdale's, one of New York's finest department stores, set up a complete 'Kusama Corner'.

My Party Dress, which accommodated up to twenty-five people, sold for $2,000. The Homo Dress, with a cut-out section placed strategically in the rear, cost $15, while an evening gown with holes cut out at the breast and derrière went for as much as $1,200. I had numerous orders for my See-Through and Way-Out dresses from ladies of the so-called Jet Set – the Jackie O. crowd – and in April of 1969 I opened a fashion boutique at the corner of Sixth Avenue and 8th Street. All the clothes I designed and produced were, of course, decorated with polka dots.

The third category was related to film. Kusama International Film Production sold films of Happenings, for example, by mail. I also produced and directed new films like *Flower Orgy* and *Homosexual Orgy*, which were shown all over the country and screened in museums around the world.

The fourth category comprised all my remaining miscellaneous ventures. I established the Body Paint Studio, for example, under whose name we acted as a sort of modelling agency, and the homosexual social club KOK. KOK stood for Kusama 'Omophile Kompany, a tortured acronym invoking the slang term for the male organ.

During this year I demonstrated body painting on *The Tonight Show Starring Johnny Carson.* I also appeared on the popular *Alan Burke Show,* leading four nude performers – three women and two men – in a true Body Paint Happening. And in December, in front of a full house of four thousand people at the Fillmore East Theater in New York, we staged the *Kusama Self-Obliteration Musical,* a Happening that also involved naked body painting.

This series of projects met with increasing success in the USA and even received fairly accurate reviews in the media. But the image of me that was making the rounds across the Pacific, in Japan, was based entirely on misunderstanding and prejudice: I was referred to as the 'Queen of Naked Happenings' and 'a national disgrace'. My performances, which for me were about art and ideas, were never reported in Japan as anything other than outrageous scandals. One direct result of this was a serious rift with my family. Until this point my father had managed to smooth things over enough with my mother to occasionally send money, but I was given to understand that such assistance would no longer be forthcoming.

—

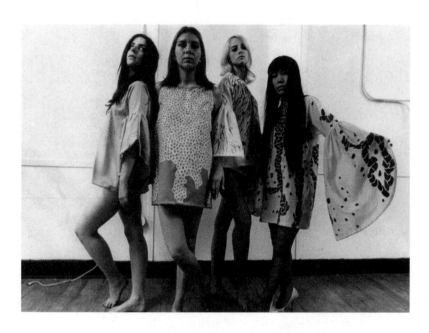

**'Kusama Fashion show' at my
studio**
New York
1968

—

THE DRUNKEN GODS
Sung on stage at the *Kusama Self-Obliteration Musical*
—

Even if the phantasmal spirit dies in an agony of neurosis
before it reaches the seminal sac
always idle to all appearances
but with an endlessly restless edge
my poor penis is not all I would wish
Ovaries always prefer indolence
and daytime affairs cause drowsiness
Spermatozoa strike just when you've forgotten about them
poking their faces through the treacherous hole
never forgetting clamoring for attention
dropping in to say hi History repeating itself

REFRAIN:
That's why men should all become homos
Ladies, let's all become lesbians

I guess the gears don't mesh
Coitus always getting interrupted
Love and Death all alone
forgotten and left behind
Weren't Heaven's waters dried up
when we happened to drop in?
All we wanted was to climb love's summit
Enough already When you resign yourself
The neck of the vas deferens dripping blood

REFRAIN:
That's why men should all become homos
Ladies, let's all become lesbians

—

The corpus spongiosum rages in a sea of fire
The foul nerves of the glans penis
Endless seige of sperm
Listen Even in love
vaginal nights unleash their fury
Off Staten Island
rip the panties from Lady Liberty
How could you? they whine
But we never had any bouquets
between us

Refrain:
That's why men should all become homos
Ladies, let's all become lesbians

O God if you're really there
sprinkle silver dust on
the seedy lust of men and women mingling
Shove in some dry ice
Tell them to cool it and share a carriage
The planet is out of whack
How many more billions of years do you intend to prosper?
Slice the snake into rounds
The womb is the door to Hell

Refrain:
That's why men should all become homos
Ladies, let's all become lesbians

—

Body Paint
Enterprises

—

I did not let the misunderstanding or prejudice deter me, however, but continued expanding the scope of my art and ideas. What I might call my 'Body Paint Enterprises' comprised various companies through which to channel my creative energy. One of these was called the Nude Studio, though it bore no relation to the peep-show joints that use that name in Japan. At my Nude Studio we did not treat the audience to a show, but rather a chance to participate in body painting.

The models who served as canvases were of course completely naked, so that even if participants had no interest in painting they were able to enjoy a close inspection of every nook and cranny of those lovely young bodies. We also encouraged the audience members to strip and paint one another. When only the models got naked we charged $18 for an hour or $10 for thirty minutes, $25 or $15 when the customers too got naked and polka-dotted. With thirty beautiful hippie girls on call, we had the biggest operation of its kind in New York.

Next was the social club KOK. All the members of KOK were gay men, and they were free to enjoy 'romantic love' at the meetings. Even the media praised the club, calling it 'the newest type of homosexual organisation' and honouring (?) me as 'the Japanese flower who holds sway over some four hundred homosexual men'.

Then there was the Orgy Company, also known as the Kusama Sex Company. The main business of this enterprise was to serve the citizenry by hosting group sex parties and selling such items as oversized photos of female reproductive organs. Giving those who had never experienced orgies the opportunity to see and participate in them was a significant contribution to the sexual liberation of the American people. It was widely believed that only hippies attended my parties, but in fact the majority of participants were businessmen. Prominent professional men – doctors, lawyers, university professors, and so on – also attended frequently. Such people, who had public reputations to maintain, could not flaunt girlfriends or fool around at will, so they would come to my

—

place to watch and join the nude action in private. Some even brought their wives.

By mail order, we sold 'spread shots' – photos of splayed vaginas – and various sex aids and toys. A set of twelve life-size spread shots went for $5, and a much-enlarged poster sold for between $3 and $5.

The Nude Fashion Company was an offshoot of Kusama Fashions. The main product of this enterprise was the Party Dress, with holes cut out at the breasts and crotch to allow the wearer to have sex without disrobing. There was also a sleeping-bag-like Couple's Dress, the idea being that clothes should bring people together, not separate them. The goal of the Nude Fashion Company was to expand distribution of these dresses, being based on fresh ideas and practical for enjoying sex, into the mainstream.

I used these fashions in various kinds of events. At one Happening, for example, thirty men and women climbed inside a single, enormous dress made of Soviet and American flags, and then, on the count of four, leaped into the sea and began making out and groping one another in the water. For a time, whenever working in my studio, I wore a one-piece dress with holes of 20cm across at the rear, the breasts, and the crotch, and my male assistants worked completely naked except for a pouch of printed cloth covering their three-piece sets.

Through our film production company we made films that related to sexual liberation. I produced, directed, and starred in a number of them, beginning with *Kusama's Self-Obliteration* in 1967. The awards these films won at festivals around the world attested to their high artistic standards, just as the great number of screenings attested to the many devoted fans of my art.

I also ventured into the publishing business, putting out a weekly newspaper called *Kusama Orgy*, of which I was the chief editor. The theme of the paper was 'Nudity, Love, Sex, & Beauty', and it was sold at news stands all across the USA.

Why did I submerge myself so completely in such a wide range of projects? The answer is simple: I was merely doing what everyone wanted to do. This was obvious from the abundance of articles about sex and the photos of naked women in newspapers and magazines. Nonetheless, the medieval mindset that sex is dirty and not to be freely enjoyed still held sway. People were suffocating. In my opinion, just as starvation leads to crime and violence, the suppression of sex twists the true nature of human beings and is an underlying force that pushes people towards war. My hope has been to help those who are being crushed under the iron heel of abstinence.

At the time, the USA – to say nothing of Japan – was still far from being sexually liberated. Of course, the road to complete sexual liberation is a long one.

Whatever people may say, I believe that the present situation, with sex pulled from its pedestal and looked down upon while all the males jerk off, is contrary to the wise providence of Heaven. We must have a sexual revolution, at all costs. In order to accomplish this I felt I would have to work like mad, and so that is just what I did.

The 1960s:
A Huge Turning
Point

—

I had ardent fans not only in the USA but around the world, and I was reported on almost as much as Jackie O. or President Nixon. My name was in the tabloids day after day, magazines carried stories about me, and the public was fascinated by my activities and movements. This said a lot about where people's real interests lay and proved how starved they were for Love and Peace.

My role was to nudge all these people toward a sexual revolution by supplying a space and opportunity for them to enjoy free sex. In enabling these encounters, I acted rather as producer and director.

It was not an easy task to promote this sort of movement among people who had been tormented with repression and sexual bigotry all their lives. Most daunting was the stubborn police oppression. The police persistently came down on us, and often more than a few people in the crowds were on their side. But if asked which they thought preferable, war or free sex, even the hecklers would have chosen sex.

As I put my ideology into practice, my Happenings escalated towards even greater extremes. In April 1969, in Sheep Meadow in Central Park, we held a Happening called *Bust-Out*.

On Easter Sunday the artist Louis Abolafia and I conducted a Happening to kick off our campaign for the mayor of New York City on the Love and Nudity platform, both of us appearing with polka dots all over our bodies. I was wearing only a bra and a belt. Some of the spectators fought playfully over the orgy dresses. The *New York Times* reported that some four thousand hippies attended this Happening, while the *Daily News* featured it under the heading 'Naked Easter Demonstration'.

In August we staged a performance in the garden of the Museum of Modern Art titled *Wake the Dead*. This was a Happening in which eight naked participants struck dramatic, statue-like poses in the fountain of the sculpture garden. In the press release I wrote:

—

—

At the museum you can take off your clothes in good company: RENOIR, MAILLOL, GIACOMETTI, PICASSO. *I positively guarantee that these characters will all be present and that all will be nude.*

For me, MOMA was the Mausoleum of Modern Art. What did the word 'modern' mean in a place like that? Van Gogh, Cézanne, and all the other ghosts were either dead or dying. The real artists who were alive today might die while the museum was exhibiting the work of the already dead. That was the way I saw it.

The four men and four women were standing by. When I gave the signal, all eight tore off their clothes and stepped naked into the reflecting pool, where Maillol's *The River (Girl Washing Her Hair)* was installed. Also positioned around the garden were sculptures by Picasso, Henry Moore, and others. One of the women lay back, spreadeagled on Maillol's sculpture. Her sex organ was completely exposed to the two hundred or so spectators. One of the men then lay on top of her. His lips joined hers in a kiss, and their sex organs met, although there was no penetration. From behind, his two round balls blocked her organ from view. Another pair embraced as they leaned against the sculpture, and the other two pairs coupled in different positions on the edge of the pool. I stood beside them declaiming, 'Let's make love! Let's make love!' and lecturing the crowd: 'This is an act to destroy Power in the name of Art.'

But this Happening, too, was cut short. A museum security guard soon came running and began pulling the naked couples apart.

The next day, 25 August, the *Daily News* covered this event with a front-page photo and article.

But Is It Art?
Security officer Roy Williams pleads with nude young men and women to leave Museum of Modern Art fountain, where Maillol's sculpture, Girl Washing Her Hair, *reclines. Impromptu nude-in was conception of Japanese artist Yayoi Kusama. Crowd takes it in stride. (Some took strides to get closer.)*

The article went on to say that it took some twenty minutes to drag the naked performers from the fountain. The woman who had exposed herself on Maillol's sculpture later recalled her feelings: 'The water in the fountain felt wonderful. I'm a designer. This was my first Happening.

—

146

—

But I consider Kusama my comrade-in-art, and I had no compunctions whatsoever about getting naked. I can't wait to do it again!'

Right through to the end of 1969 we put on many such performances – orgies, Happenings, and fashion shows followed by sex parties at the studio. And so the 1960s, a huge turning point, came to an end.

The French philosopher Félix Guattari had the following to say about my art in an essay published at about this time:

> While Yayoi Kusama's works exude the power of an imagination rooted in a tradition that is particularly Japanese, they also constitute astonishing devices for exploring the subjective and aesthetic potential of the most modern materials – those same materials with which, let us not forget, the consumer society litters its wretched and disenchanted universe. Yayoi Kusama re-enchants our world. She burst forth in refulgent fashion – but at what cost to herself! – during the creative-destructive era of the 'Beat Generation.' Now she has been reborn before our eyes as a great contemporary artist forging the sensibilities of a most unpredictable future.

Japan after Thirteen Years

In 1970, thirteen years after escaping Japan at the age of twenty-seven, I returned for a visit. My intention was to create in my own country the same sort of 'nude revolution' with which we had had so much success in the USA. I had received word of the extreme and outrageous reports about me in the Japanese mass media, however, so I was not certain how my ideas and activities would be received there.

I placed great importance on newspaper, magazine, and television coverage in order to quickly expose large numbers of people to my movement. The media in the USA and Europe reported on my activities in a relatively accurate way, but, to my great dismay, it was quite the opposite in Japan. My movement was distorted and misinterpreted by the Japanese media, who seemed interested only in exploiting me and whose reportage did nothing but sully my image.

I already knew how base and cowardly members of the Japanese media could be. Japanese writers and photographers were constantly popping in and out of my office in New York. They would fawn on me, saying things like: 'You're misunderstood in Japan – some even call you a national disgrace – and I want to correct that perception.' I often arranged for them to witness orgies and Nude Happenings. And yet, though I went out of my way to accommodate these people in various ways, even helping them with lodging and meals, they thought nothing of turning around and stabbing me in the back.

A photographer named 'K', for example, made free use of my staff, failed to show up for appointments I had arranged, and disappeared without so much as a thank you, then proceeded to publish his photos along with a tale of how he had 'infiltrated' a secret sex party, never mentioning the fact that he had received my full cooperation. His comments appropriated my ideas word for word, yet he never so much as mentioned my name in his article.

The *Shukan Post* published a piece about me that was utter nonsense, attributing to other people photos that I myself had supplied.

Then there was the unprincipled character who went around selling photographs that I had taken as if they were his own work. The programme *11 P.M.* on Nippon Television showed, without my permission, photos that had been stolen from my studio office by 'K' and another man named Nakane, as I later discovered. There were countless more such cases, and I became thoroughly disgusted with the sleaziness of the Japanese press.

Writing for *Shukan Bunshu*'s 'Extraordinary People of the Showa Era' series, a man I shall call 'H' unleashed a variety of slanderous accusations against me. He began by quoting me as saying that 'sleeping with people is a form of strategy'. I had never met this man. I am sure he must have taken at face value the irresponsible whining of certain impoverished New York-based Japanese artists who begrudged me my success. *Shukan Shincho* also reported a number of scandals in which I was supposedly involved. I could not say where they got their information, but these articles too were brimming with malice and totally devoid of truth.

I have never tried to influence anyone by sleeping with them. I have always believed that if a woman sleeps with a man in the line of work, it is all over for her. In America, women artists do not have sex with critics or journalists or patrons. Once a woman sleeps with a man, she loses her only weapon; if she does not give it up, on the other hand, she can use a man for ten or fifteen years.

In addition to all the journalists and photographers who called on me in New York, there was a procession of Japanese artists and entertainers, many of whom promptly appropriated whatever information I provided for them. They presented my ideas as their own in essays or lectures and generally ignored all common courtesy in their dealings with me. So it was with the Japanese visitors who looked me up in New York – most of them, I believe, were scum. Even my American friends were repelled by their behaviour. But the malicious reports went beyond mere nuisance when they incited attacks on me and on my family in Japan.

The morning after my body-painting exhibition in the garden of MOMA, the sign at the entrance to my office on Sixth Avenue was vandalised and a stone was thrown through the window, shattering the glass. Outside were five or six staggering-drunk Japanese men who shouted at me before hurrying away, 'You're just famous for getting naked! Treacherous bitch! You should be deported!'

Whenever news of me reached Japan it caused my family shame and distress. My old-fashioned father wrote me a mournful letter asking 'Have you really sunk this low?' My mother, too, was forever bombarding me with tearful remonstrances. 'The hardest part is seeing neighbours or local tradesmen making every effort to avoid asking about you,

because they've read the articles in those magazines.' In another letter she went so far as to say: 'The fact that you have become a national disgrace is an insult to our ancestors, Yayoi, and I've just returned from the cemetery, where I went once again today to ask their forgiveness. If only you had died of that bad throat infection you came down with as a child....'

Both my mother and my father believed every word that was reported about me in Japan. That, for me, was the saddest part.

Now, for the first time in thirteen years, I was about to step on Japanese soil, where an antagonistic press awaited me – a media machine that was not interested in my art or ideas, but interpreted everything I did as disreputable.

Japan:
Still a Man's World

Disembarking the Northwest Airlines flight at Haneda Airport at ten o'clock in the evening of 6 March 1970, I was surprised at how cold it was. 'N', a reporter for the *Shukan Post,* was the only one there to greet me, but this was to be expected. I was travelling incognito.

I had set up a meeting with a lawyer for the very next day. I needed his advice because my goal was to conduct Happenings that would stun Japan, with a view to liberating her sexually backward people, and I wanted to be on solid legal ground. I could have handled being driven out of the country, but it would have been a disaster if I were prevented from returning to the USA.

I was contemplating various different types of Happenings, including a 'Homo Parade' to take place at *Expo* '70 in Osaka. The culmination would be a massive 'Nude Panorama' in front of the National Diet building in Tokyo. By staging such events, I hoped to provide the opportunity for a mass, nationwide people's movement.

Even if the Happenings in front of the Imperial Palace and other such notable locations ended up being thwarted by the police, the reporting of this around the world would fulfil at least a portion of my goal. I would use the press to shake up the mouldering morality that dominated the country. I had to perform for the people of Japan, and the world, the same sort of revolutionary work I had done for painting and sculpture. That, I felt, was my mission. My nude body-painting events had found a massive following in the USA and Europe; even I was surprised at how many imitation Kusama Happenings were now being held around the globe.

My first big surprise, on walking on Japanese soil after such a long absence, was the degree to which men were still throwing their weight around. I would flag down a taxi, and a male citizen would step in front of me and take it for himself. My first reaction to such discourtesy was not anger so much as dumbstruck amazement. Here I was, already anxious, in Tokyo, a city I did not know very well, with taxi drivers yelling

at me and total strangers being utterly obnoxious. I felt like beating the bastards' backsides with a baseball bat – then castrating them all and banishing them to a penal colony on some island like Hachijojima.

When I looked at Japanese magazines, I saw that they were full of nude photos of women and articles about sex. But did this mean that a sexual revolution was under way? Not in the least. Respectable women of my mother's and grandmother's generations had to preserve their honour and be absolutely faithful to their husbands, turning a blind eye to the fact that their husbands were fooling around with other women. And, ridiculous as it may seem, that had not changed at all.

Rather than being bound by what others thought of you, or by some outdated morality, I believed, it would be better to pack your bag and hit the road. Even if it meant begging for food or sleeping in the open air: the important thing was to live your life doing as you pleased. Just as I had done. At my *Burn the Panties* Happening in New York, Mary had set her underwear on fire. Japanese women, too, needed to strip off their panties, set them ablaze, and liberate themselves sexually. The wife whose husband has left her weeping should herself go and participate in an orgy, or openly attend partner-swapping parties.

The University of Tokyo, with its famous Red Gate, was in my opinion nothing more than a symbol of male chauvinism. I believed we should tear the whole place apart and turn it into a platform for teaching the arts of homosocial and sexual intercourse. I was even prepared to bring my gay friends from New York and set myself up as the first female president of the school. In any case, I felt that most Japanese, both men and women, were essentially ignorant about sex and completely repressed.

A group of a dozen or so prominent Japanese businessmen once came to New York and were keen to witness a body-painting party at my studio. They peered at the models' lower bodies and squawked: 'Oh! Sure enough, she's blonde down there, too!' They even inserted their fingers, simpering and gasping: 'It's so deep!' I wanted to kick these geezers right where hurts. And it was clear that the models felt the same way. As soon as the businessmen left, the girls began complaining: 'What was that about? I've never seen such a filthy-minded bunch!' Following this incident, I posted a sign on the studio door saying 'No JAPANESE ALLOWED'.

How I would love to blow the lid off these repressed attitudes toward sex! That is what I was thinking the whole time I was in Japan, and so I accepted media interviews day after day – weekly magazines, newspapers, TV, whatever.

On 12 March I appeared on Nihon Educational Television's *Nara Kazu Morning Show.* A female anchor jokingly asked, 'What sort of underwear are you wearing?' She did not realise that she was giving me the perfect opening for something I had planned to do anyway. 'Shall I show you?' I asked, bouncing to my feet and peeling off my panty stockings. 'Here!' As I was doing this, a male assistant jumped in front of the camera, and I could see that the cameraman too had panicked and pointed his lens at the ceiling. The result, unfortunately, was that my naked womanhood (I wasn't wearing panties of any sort) did not make it to the screen. And all I had wanted to do was to defuse the sense of sin lurking behind Japanese attitudes toward sex.

For the Imperial Palace event, I stood in front of Nijubashi Bridge, pulled off my tights and spread my legs. I told the photographers to shoot the bridge framed between my legs, and the shutters began clicking. But as tourists in the passing throng stopped to gawk, the photographers hustled me away from there. Once again, no one had any true understanding of what the Happening was about.

Day after day, night after night, I was caught in a whirl of media events. I could not help wondering why, in interviews or press conferences, Japanese journalists never tired of asking the same old questions. They had no understanding of the substance or significance of what I was trying to do. Nor did they care. The only measure they applied to my actions was the perceived degree of prurient interest. What can one say in response to such superficiality?

Busted after Midnight

Late at night on 13 March I was walking along the Ginza with three girls. When the moment was right I gave the signal, and the girls flung off their coats. They were topless underneath, one wearing slacks and the other two only panties. I now encouraged them to 'Go wild!' They raised their arms in *Banzai!* poses and frolicked about, leaping and spinning. I had painted their bodies beforehand with beautiful polka dots. I was urging them on when a man's voice said: 'What do you think you're doing?' It was a policeman in a patrol car. 'This looks like public indecency,' he intoned. 'I'll have to ask you to accompany us to headquarters.' They took all four of us to the police station in Tsukiji. It turned out that a passer-by had phoned in to report us.

And so, sadly, we had to lower the curtain on our Midnight Happening Show as well, after only a minute or two. 'What did I do? I have no business with the police!' I shouted, but it was wasted on the cops. I happened to have some US dollars in my pocket and took them out, thinking that that would settle things, but a weekly magazine reporter who was standing nearby told me that if I offered money it would only make things worse. 'They'll get you for attempted bribery,' he said. I was used to New York, where the police always released me if I slipped them a few banknotes.

Be that as it may, the interrogation we were subjected to in Tsukiji was a complete travesty. Beneath their coats, the girls were still naked from the waist up. From the time we were brought in until four in the morning, the cops kept badgering them to 'Open your coats and let us see what you were flashing'. Perhaps the Japanese police did not accept bribes, but they were drooling to get a free peek at bare breasts. One of the girls finally started weeping. The policemen got a big kick out of this and continued urging her to 'Open up!' Finally, after a long and tiresome lecture, they let us go. Still, I could not help thinking what a truly hopeless case Japan was.

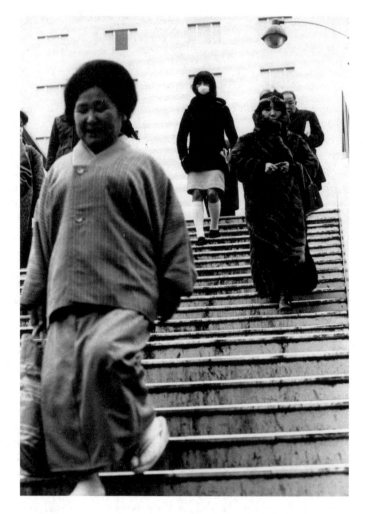

Temporary return to Japan
Tokyo
1970

—

I was in my motherland for a little over two months, but all my stay did was confirm for me what a corrupt and bogus, fourth-rate country it was. In the end, the concept of free sex was something the Japanese simply could not grasp. This was true not only of the elderly and hidebound, but even of the younger generation. Japanese men, both young and old, were enslaved by an 'any hole will do' mentality that was the product of sexual starvation.

Free sex is about confirming the existence of others and forming a connection through the most human of behaviours. The Japanese did not understand that this was a human revolution. Free sex is a confirmation of human love, and of equality. In sexual pleasure, there is no black or white or yellow. Why would people need to go to war and kill one another when they could be giving one another pleasure? Through free sex, you could tear down the barriers between Self and Other: that was the important thing.

But when all was said and done, my pro-sex and anti-war ideas, and the Happenings that expressed them, went down like lead balloons in Japan. The mass media, the journalists, and the intellectuals all exhibited absolutely no comprehension of what I was about. Ruminating that ever since the days of Jesus Christ, no revolutionary has ever been welcome at home, I left Japan behind once again.

Throughout 1971 I shifted my main activities to Europe, flitting about from city to city. With Rome as my base, I set up a huge number of body-painting performances, fashion shows, and solo exhibitions. Meanwhile, back in New York, my films *Kusama's Self-Obliteration* and *Flower Orgy* were causing a sensation at the First Annual Erotic Film Festival.

I reclaimed New York as the home base for my activities in 1972. This was the year my name was first listed in the American *Who's Who*. I have been listed each year ever since.

In 1974, my father died.

—

Part 4

—

People I've Known, People I've Loved

—

Georgia O'Keeffe,
Joseph Cornell,
Donald Judd,
Andy Warhol, and
Others

—

Georgia O'Keeffe

My First and
Greatest Benefactor

Of all the many remarkable people I have known in my life, the first I must mention is Georgia O'Keeffe. If she had not so kindly answered my clumsy and reckless letter to her, I am not sure I would ever have made it to America. She was my first and greatest benefactor; it was because of her that I was able to go to the USA and begin my artistic career in earnest.

Georgia O'Keeffe was born in Wisconsin in 1887, and by the age of ten had decided to become an artist. She studied art in Chicago and New York, and became interested in Oriental art in her early twenties. She was teaching art and working on her own paintings when some of her abstract works caught the eye of the photographer Alfred Stieglitz. In 1916 he hosted an exhibition of her work at his own gallery, 291. O'Keeffe and Stieglitz married in 1924. After his death in 1946, O'Keeffe moved to New Mexico, where she lived an isolated life, rarely seeing anyone. She painted an enormous number of pictures – flowers, New York cityscapes, desert scenes, animal bones – before she passed away in 1986 at the age of ninety-eight.

When I moved from Seattle to New York, I was thrilled to be in the city of my dreams. But New York was not remotely like post-war Matsumoto, and the ferocity of the place was such that I repeatedly plunged into severe bouts of neurosis. It was during one of these that O'Keeffe took the trouble to write me a letter in which she said that if I was finding New York so difficult to live in, I should come and stay at her hacienda in New Mexico. She enclosed photos of her house and garden, to give me an idea of life there. I was, and still am, astounded by such kind consideration for someone she had never even met. I can

only attribute her kindness to her interest in the arts of Asia in general, and Japan in particular, and to the fact that I must have struck her as such an oddity – a Japanese girl coming to America all on her own. In those days such a thing was unheard of in Japan: people were intent only on securing enough to eat, and those artists who did make it to America worked as labourers. The dream of painting pictures in the USA was an extravagant one, to say the least.

My situation must have touched a nerve with O'Keeffe; perhaps she saw something in the works I had sent her.

She once paid me a visit in New York. This was in 1961, when I was in my fourth year in the city and living at 53 East 19th Street, in mid-town. I received a telephone call saying 'I'm on my way'; ten minutes later Georgia O'Keeffe was at my front door. I wanted to get a photo of us together, but my camera was out of film and there was no time to go out and buy a new roll, so I missed my chance. How I regret that now! My first impression was of the wrinkles on her face: I had never seen so many. They were about a centimetre deep and reminded me of grooves on the soles of canvas shoes. But she was a lady who simply exuded refinement. There was something truly noble and dignified about her.

'I'm Georgia O'Keeffe,' she said, stepping into the room. 'You must be Yayoi. How's everything going?'

Her bone structure was sturdy and angular, and in her quiet bearing was the proud loneliness of a great artist. She did not bustle about when she moved, but walked in a measured way. On her chest was a brooch by Alexander Calder.

O'Keeffe was very solicitous of me, asking if I was having a hard time making ends meet and if I wanted to come to her place in New Mexico. Though a very solitary person herself, she had gone out of her way to call on me and express concern for my welfare. She told me she would be happy to offer me room and board, but I reluctantly declined because I knew that only in New York could I become a star. New Mexico seemed far away and remote. To get to New York, O'Keeffe had had to travel 70 miles of dirt road from Abiqui to Santa Fe before boarding an eight-hour flight.

The scenery in the photos she had sent me looked as if it was in old Mexico. I was told that when the wind blew, tumbleweeds danced and whirled around, and the torrid air hit you like a furnace blast. That O'Keeffe was able to live so far from the centre of things and still maintain her fame and her status was a testament to the greatness of her art and how deeply it affected people.

Her life was solitary almost to the point of eccentricity, and yet

whenever she came to New York from then on she made a point of meeting with me. I was probably the only Japanese she ever associated with. She was a rare person, so admirable on so many levels. She once gave me a watercolour of a flower, but it later got lost during a move. What a pity! I regret losing that piece so much that it hurts me even now to think of it.

Georgia O'Keeffe is among the top artists in history, and her paintings attained the very highest level. She possessed a certain genuine and deeply embedded spirituality, and it is largely to this that I attribute her greatness.

O'Keefe and *Nihonga*

—

Georgia O'Keeffe was sixty when she first visited Europe. She said that when she saw Mont Sainte-Victoire, which Cézanne painted so often, she was taken aback and thought, 'So that's what Cubism's all about' – it struck her as such a bland little mountain.

To the American public O'Keeffe came as a tremendous shock. The country had never produced paintings like hers before. American painters liked to fill their surfaces with detail, and no one had thought of leaving space the way she did. Even now, among American women artists, she retains her place at the very top. It takes a rare person to build that sort of status while remaining absolutely true to herself.

I believe that she was influenced by Japanese *Nihonga*-style painting. Some might classify her work as Symbolist – I think of it as Surrealist Symbolism – but her flowers are *Nihonga* flowers, with space opening around them, and even the leaves are Oriental. Her method was to paint only what she wanted to paint.

In her final years O'Keeffe developed a degenerative eye disease for which there was no cure. But even as her vision failed her, she would gaze at the sky with unseeing eyes and paint the shapes of clouds.

She was a solemn and austere person in a sense, very fastidious and self-contained. At her ranch she commanded a staff of five or six assistants and gardeners and tended an extensive vegetable garden in which no chemicals of any sort were used. She only ate these untainted vegetables.

—

—

One day late in her life, a young man of twenty-two came to the ranch looking for work. He ended up becoming both O'Keeffe's business manager and her closest confidante, and he spared no effort in taking care of the nearly sightless artist. Moved by his devotion, O'Keeffe decided to put him in charge of all her affairs. She was eighty-six at the time.

Up until then she had always dressed in black, like a nun, but the young man employed a designer and began selecting lovely and tasteful outfits for her to wear. Shortly before she died, he brought O'Keeffe to his own house and cared for her there. O'Keeffe had no children or close relatives, but the young man treated her like family, doing everything he could to make her comfortable. And yet there were people around who harboured groundless suspicions, saying that he must be after her fortune and that he would show his true colours when she passed away. But even after O'Keeffe's death he behaved impeccably. He created a proper foundation, with himself as director, and conducted the affairs of her estate in a more professional manner than even she had done while alive. He also built a museum in her honour.

Near the end of her life O'Keeffe rewrote her will almost daily: so much to so-and-so, this piece of real estate to someone else, the vacation house not to X after all but to Y, and so forth. I imagine she did this simply because, not being able to see, she had nothing else to fill each day. But when I heard later that the estate was divided up exactly as her final will had prescribed, I was happy for her. Georgia O'Keeffe was a truly extraordinary person, and an extraordinary artist.

—

Joseph Cornell

'Joseph Something'

'In a couple of days, I'm going to meet the most remarkable person,' a lady art dealer said to me one day in 1962. 'But, Yayoi, he's only allowing the meeting on one condition: that I bring you along and let him have a look at you. So you're going to come with me. And I want you to wear your most beautiful outfit.'

She told me that the man was extremely eccentric and reclusive. Dealers clamoured for his art, but he remained indifferent and refused to sell. The only way to soften him up was to bring a beautiful young woman along. That, she told me, was why she needed me to go. She had already advised him that she was bringing an attractive Oriental girl.

I wore my finest kimono, with a silver obi, on the day of our visit, but I still did not know who the person we were visiting was. Joseph Something.

We made our way to a lonely country town, worlds away from Manhattan, and to a tract house that stood alongside dozens of others just like it. This was Utopia Parkway in Queens. The dealer led me around to the back of the house. She knocked, a man's voice responded, and the door opened. Inside was the kitchen, where the man had been having a cup of tea. He was introduced to me as Joseph Cornell.

Joseph Cornell was born in Nyack, New York in 1903. When he was thirteen his father passed away, and he began working to support his mother and his little brother, who suffered from cerebral palsy. In 1931, after discovering the work of Max Ernst, he decided to follow the path of art. Throughout the 1930s Cornell associated with émigré Surrealist artists while creating his mysterious boxes, using collage and assemblage techniques. He died in 1972.

—

We discovered that Cornell and I had both participated two or three months earlier in a group show at the Gertrude Stein Gallery in New York, along with Allan Kaprow, Lee Bontecou, and others. But this was the first time we had actually met. He was in his late fifties and struck me as frightfully old. I suddenly remembered that, if I was not mistaken, he was also the artist who had created the poster for a Surrealist exhibition at the Julien Levy Gallery – a picture of a boy blowing a trumpet from which the word 'SURREALISM' echoed telescopically.

His house, in the classic faux-colonial style, was unmistakably American, but the interior had a European atmosphere. It was all start-lingly different from the world I knew in Manhattan. This was the home of a man who had been influenced by the many European refugees in the USA, and who had grown passionate about his art after falling under the spell of Ernst's collage-novel *La femme 100 têtes*. Perhaps that explained why the place was so different from other artists' homes I had visited, all of which had an open and welcoming air that struck me as characteristically American.

A bashful blush coloured his lugubrious features. 'This is the girl? The one whose work was next to mine at that group show? Come in, come in!' He gazed at my gorgeous kimono and softly touched it as he ushered us inside. 'You are a beautiful girl,' he said to me. Then he turned to the art dealer and said, 'I really must thank you for introducing me to such a lovely person.'

Inside the house, Cornell's artworks were everywhere. His work-room was a disorderly mess, with all sorts of wooden crates and sweet boxes and tins piled against the eastern wall. Each of these receptacles held a different type of material – seashells, pebbles, sand, old nails. He also had floor-to-ceiling stacks of magazines from which he harvested the clippings he used in his pieces. These magazines, which he bought on the cheap at secondhand bookstores, were full of photos of the 'classic' beauties of which Joseph was so fond.

If he needed seashells for something he was working on, he would take them from one of his crates. Inside would be perhaps a hundred shells of different shapes and sizes. Whenever he went for a walk he would pick up bits of wood, rusty nails, and suchlike – anything old. He would carefully place these treasures in the paper shopping bag he always carried and take them back to his studio. He also kept empty wine bot-tles full of sand he had dyed red or blue. Eventually he would use these scraps and materials in spectacular works of art.

The balls perched on the metal rods in *Birds Navigating the Sky* he had bought at a cheap general store and painted white. The old nails

—

holding the clay pipe were also daubed with paint. This piece, completed in 1963, was replete with what would later become known as 'do-it-yourself' features. It was constructed so that you could take it in your hands and roll the balls about.

Surrealist Box, from 1951, was another interactive piece. It comprised a sheet of paper slit in some seventeen places with a sharp blade, and two or three rings embedded in blue sand. If you held the box and tilted it or moved it laterally, you could create any number of different compositions. I once owned a box of Joseph's that was similar to this. The extraordinary thing was that you never tired of looking at it.

What was wonderful about his works was that the contrivances were based on the most mundane of objects, inviting the viewer to grasp the true charm of collage and assemblage.

From 1946 to 1948 Joseph was already constructing versions of his *Multiple Cubes.* One can only wonder at the sensitivity of his antennae, in view of the fact that some twenty years later the idea of multiplicity would conquer the New York art scene.

I was walking near 3rd Street and Fourth Avenue one day, looking for a frame for a piece Joseph had given me, when I happened to enter a second-hand bookshop. I was immediately assaulted by a crackling vision, sparked by a hint of the same odour I always encountered on walking into Joseph's workroom. I looked up toward the ceiling and thought, 'Aha!' Hanging up there were row upon row of old picture frames and broken boxes of the sort Joseph used, selling for a dollar or fifty cents each. Some of the frames were so old that the corners were splitting. Joseph would buy frames like this dirt cheap, then use a knife to further widen the gaps. This made them look even more ancient and gave them an added flavour. When he used new nails, he would always slop paint on them after pounding them in. This camouflaged their newness to avoid disrupting the nostalgic atmosphere of the whole.

In his studio were only the simplest of tools: a vice to hold pieces of wood for sawing; pairs of pliers; two or three hammers; and saws of various sizes. There was also a basin full of dirty coloured water, into which he dipped new objects to give them a look of age.

Joseph was a box maker of astonishing genius. His boxes looked as if they might fall apart at any moment, but they were never really in danger of doing so. He secured them from behind with proper new nails and outfitted them with a variety of tricks and contrivances that at first you would not notice.

The apparent fragility of the pieces is what made European collectors of his works hesitate to loan them out to travelling exhibitions – for

fear that they might be destroyed in transit. But Joseph's boxes were professionally made and more than sturdy enough to withstand a little travel. That is the skill of a true artisan. The boxes were not just thrown together; they involved a lot of precise and delicate work and required real power, however small in size they might be.

'My works have more in common with Nerval than Lautréamont or Roussel,' Joseph himself once stated. In terms of technique, his work clearly resembled Marcel Duchamp's 'readymade' and Surrealist *objets,* but it was free of the irony typical of Europeans. Overall, he possessed a genuinely lyrical quality, as can be seen in works like *Parrot and Butterfly Habitat*. This peculiar lyricism of his was something the Europeans lacked.

Love Calls

To return to the time we first met, Joseph – who despised art dealers – sold the woman one of his boxes out of gratitude for her having brought me to meet him. Knowing that he would only sell his works for cash, the dealer had come with her handbag stuffed full of banknotes. Once she had taken possession of the box, and before he could change his mind, she hurried back to the city on her own. That left me alone with Joseph, whose stare was boring holes in me. And then, with such a serious face that it was impossible to write the words off as mere flattery, he said: 'You are the most beautiful and adorable Japanese girl I've ever seen.'

The day after we met, Joseph began churning out poems whose intent was to establish a relationship between us. I was quite taken aback by the number of poems he sent me – my mailbox literally overflowed with them. But they all evinced the same sort of lyricism on display in his artwork.

You could count on your fingers the number of people in New York who had met Joseph. His reputation and the price of his works were soaring, but no one really knew him. He was a sort of legendary genius. When I told people I had met him, they would bombard me with questions: 'What's he like?' 'What sort of life does he lead?' This became a bit too much for me.

Joseph's indifference to public opinion and social relations, and the extremes to which he took his noble solitude, were reminiscent of Balthus. But as an artist, Balthus never transcended common sense to the

—

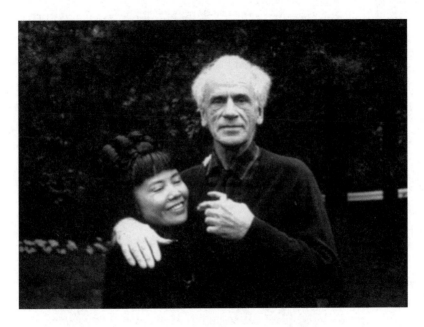

With Joseph Cornell
Westhampton, New York
C.1971

degree that Joseph had. Joseph was not susceptible to worldly matters or rational arguments. He could be exasperating, and you just wanted to throw your hands up and say, 'All right, Joseph, have it your way.' Take, for example, his telephone blitz. He would call me any number of times a day and stay on the phone forever. He would think nothing of spending five or six hours on the phone, rehashing the same simple conversations over and over. 'Yayoi, what do you think of me? Do you like me?' He kept the line so tied up that people began to say they could not get me on the phone. It even got to the point where it damaged my reputation among art dealers.

In Joseph's later years the telephone blitz got worse, and restricted me to the point where it became intolerable. But in spite of the nuisance, and although he ate up so much of my time, there was something powerfully appealing about him. And his art was simply fantastic.

He lived with his mother, a large lady whom I thoroughly disliked. She, too, was eccentric, and she harboured a passionate hatred for any woman who got close to her son. Joseph and I visited each others' homes frequently, and the moment I appeared at his house his mother's mood would visibly sour.

Joseph and I were sitting on the lawn one day, kissing, when his mother came up behind us with a bucket full of water. Huffing and puffing, she raised the bucket and emptied the contents on top of us. This, of course, brought us down to earth with a crash. I was completely drenched, from the hair on my head to the hem of my pretty lace dress. Joseph was drenched too, of course. But his immediate reaction was to cling to his mother's skirt and plead with her: 'Mother, I'm sorry! Forgive me. But this person is my lover. Please don't do such outrageous things!' He apologised to her and not to his 'lover', who was sitting beside him, soaked to the skin.

His mother, for her part, wasn't backing down. 'How many times do I have to tell you, Joseph?' she shouted. 'You mustn't touch women! Women are filthy! They breed syphilis and gonorrhea. I've told you that again and again, and what do you do? You bring this woman into our house, and now I find you kissing her!'

Another time, after I had used the shower, she removed all the towels I had touched and boiled them in a big cauldron. We ate lunch with the cauldron bubbling on the stove and me picking at my food, fearing a sudden downpour of scalding water.

Whenever she saw the two of us alone together, the mother would call for him. 'Joseph. Joseph!'

'Yes, Mother?' he always replied.

Joseph's mother complex was incurable. He was forever cringing and repenting before the woman. Even when drenched with water, the only thing in his head was that she had scolded him; he was oblivious to me sitting there cold and shivering. If she told him to make her some tea, he would jump to his feet with a 'Yes, Mother' and be off to the kitchen without so much as a backward glance at me. I have lost count of the times I thought about giving that fat old woman a good swift kick. To me, this relationship between a man of nearly sixty and his eighty-something mother was nothing short of bizarre.

Once, unable to bear it any longer, I turned to him and said: 'Joseph, if your mother doesn't want me in this house, I'll just stop coming. Then I won't have to worry about her yelling at me. It's hard for me to take. I'm a girl from faraway Tokyo. There's no way she'll ever be able to understand someone like me.'

Joseph clung to me and begged me to reconsider.

'It would kill me to lose you,' he said. 'It would mean the end of all my dreams. For years and years I've dreamed of swearing my love to a Japanese girl, and my heart has been dancing ever since I finally found you. Now you're telling me you won't come here any more? Darling, forgive me. My mother is mad. But she's still everything to me. I know it's hard for you, but...'

It was true. This old woman, with her face full of wrinkles, her blond hair gone completely white, and her bulging, flabby flesh stuffed into a blue-and-red checked dress, was everything to Joseph.

Pure Misanthropy

—

Joseph wore the shabbiest of clothes. He always looked like a tramp shambling down the street with holes in his shoes and a crumpled paper bag under his arm. He would buy some apples or a couple of lemons, drop them in the bag and shuffle on. People on the street would turn and stare at us, obviously wondering what sort of pairing this might be.

I had moved from the building where Donald Judd was my upstairs neighbour to a studio in a nameless apartment building at 404 East 14th Street. Claes Oldenburg now lived above me, and Larry Rivers above him. One night as Joseph was leaving I accompanied him down to the foyer, and there we crossed paths with Larry, who was just

returning with a bevy of fashion models. The models, apparently thinking a hobo was in their midst, squealed and skittered out of Joseph's way. Later, Larry asked me about the 'homeless guy' and was astonished to learn his true identity.

On one occasion, as I arrived at Joseph's house he suddenly appeared, lurching out of the woods towards me. I gasped and rocked back on my heels, a chill running down my spine. For a moment I thought it was Frankenstein's monster – a withered shell of a man. He would not let anyone take photos of him. He hated photos, he hated people, and he hated socialising. A complete misanthrope, he liked his seclusion and had no desire to associate with anyone.

We were having dinner at his house one evening when there was a knock at the front door. No one got up to answer it, so the man came around back and into the kitchen. 'Mr Cornell,' he said, holding out his business card; 'I'm an art dealer from London. I'd like to purchase some of your work.' I recognised the name on the card immediately – he was something of a legend in the art world. But Joseph, without even looking at the card, said, 'I haven't a single thing to sell,' and went on placidly eating his dinner.

He always told me that he had no interest in what anyone wrote about him. But one day when he was out, I looked in his closet and found a great pile of articles about him and reviews of his work. I was astonished. It was only natural, given his fame, that so much had been written about him. But to think of him claiming he was not interested, when in fact he was saving every word!

He often praised the artistry of my work. But I think the truth was that he was not really interested in anyone's work but his own. I knew that he would eventually be recognised as a great artist, and of course that is exactly what happened. This was neither here nor there to me: I considered myself the very best in any case; and I am sure Joseph felt the same way about himself.

To tell the truth, I was dying to break it off with him. The relationship had become a great hindrance to my work. He took tremendous amounts of my time, and it never let up.

Frank Stella was close in age to me and an incredibly youthful spirit. I liked him a lot. I was changing my clothes and putting on make-up with the intention of going to Frank's house for a date, when the telephone rang. 'Yayoi!' It was Joseph again.

One evening, a friend called and said, 'Your phone's been out of service. I've been trying to reach you since morning.' But there was nothing wrong with my phone. Joseph had been calling me all day long.

—

I would tell him I was hungry and hang up the phone, and two minutes later he would ring again and say, 'I forgot to tell you ...' I would sigh and set down the receiver, go to the bathroom, then out to the diner on the corner to buy some pastries. I would amble back home, buying a newspaper on the way, and when I picked up the phone again Joseph would still be on the line, waiting. That sort of thing did not seem to bother him at all.

I thought he might have other lovers or girlfriends and suggested he find himself a nymphet, someone younger than me. He said that all the women he had ever been interested in had run away from him. Of course, the mysterious world that Joseph Cornell created would have been incomprehensible to the average schoolgirl. I suppose that is why the types he had favoured had all run away. It seems I was the only one who had not.

I loved entering Joseph's world. I thought it was a wonderful, extraordinary place. Just looking at one of his works could make me tremble, which is why, even though I was constantly feeling put upon and stifled, I could not walk away from him.

On one occasion I messed up badly. I had gone to see another boyfriend and returned at about ten o'clock in the morning to find the phone ringing. It was Joseph, of course.

'Did you forget our promise?'

'What promise?'

'We agreed to meet here, beside the vegetable stand, this morning at ten.'

It was true. I remembered now. I had made such a promise.

'I'm sorry!' I said. 'I'll leave right away!'

'Where have you been?' he asked.

'I went out to buy milk.'

I changed clothes and set out for Queens. It took me a couple of hours to get to the vegetable stand, yet Joseph was still there waiting for me. He looked as though he were dying, his face pale and dripping with cold sweat. I felt terrible, but all I could do was apologise, from the heart, again and again, 'Forgive me! I'm so sorry!'

As for the telephone issue, I asked Joseph repeatedly not to ring me so often, but it was no use. He was a tremendously lonely man, and he had no other friends. He would call every single day and keep me on the phone for hours. And then there were the letters. I would open the mailbox and twelve or fifteen envelopes with his return address would spill out. Again, I could only throw up my hands in despair.

—

Early Years with his Mother and Disabled Brother

—

There is a series of drawings by Joseph Cornell that were quite a departure for him. They were made when the two of us would sit around naked, sketching each other. The Long Island winter was freezing cold, and there we were, sitting in an unheated room without a stitch on. My teeth were chattering.

'Joseph, why don't you put on the heating?'

'We have an oil heater,' he'd say. 'It'll be warm soon.'

But that room never did warm up. Later I mentioned this to a mutual acquaintance. 'I caught a terrible cold because of it,' I told her. She replied that she had once arranged for a delivery of heating oil to Joseph's house. A truck came, and the outside tank was filled, but Joseph never even noticed. In other words, the furnace had not even been lit while we were sitting there naked. Joseph was not one to think of things like that. He was absolutely nothing like your average earthling.

He had suggested the nude sketching because he wanted to see my body, and he lost no time in getting my clothes off. 'Let's both get naked, then,' I had said. 'We can draw each other.' So there we were in our birthday suits and the unbearable cold of the Long Island winter. No heat in the entire house, and not even any decent food to eat. Joseph's shabby clothes lay in a pile on the floor of a squalid room. It was, all in all, a pretty wretched scene.

When he was a young man Joseph had supported his mother and his disabled younger brother by going to work as a salesman of ready-to-wear clothing. His office was near Broadway and 18th Street, which meant he had to commute all that way during rush hour each day, changing trains two or three times. His father, who had died when Joseph was just a boy, had been in the same business. Whenever Joseph spoke of him, his face lit up with pride. 'My father was very, very good at what he did. The number one gentlemen's garments man in New York.'

Another source of pride for Joseph was the photo of his grandfather, in full military uniform, that hung in the parlour. He often boasted that although this grandfather had never quite made the rank of general, he had distinguished himself as a hero in the Civil War. The parlour, in typical American style, had photos of aunts and cousins and other

—

family members everywhere you looked.

His house was one of about a hundred, all alike and arranged in rows – like an American version of the old 'long-house' tenements of Japan. Normally when a tablecloth gets soiled, you remove it and replace it with a clean one, but in this house they just put the new one on top of the old, resulting in layer upon layer of tablecloths.

It seems that Joseph had had a very hard life as a young man. He would wake early each morning, take his brother to the bathroom, feed him his breakfast, prepare their mother's breakfast, and then go off to his job and spend all day working. He must have been exhausted by the time he got home and yet worked on his art late into the night. He never went anywhere in his youth because he could not range far from his two dependents.

Joseph's brother loved model trains. He would grab hold of the locomotive and try to lift it, but it would soon drop to the floor, his faltering hands unable to support the weight. 'Yayoi, would you mind picking that up for him?' Joseph would ask, but the younger brother's screech would warn me off.

Joseph would implore me to show his brother my body. 'The poor boy's been an invalid all his life,' he would tell me sadly. 'He's never seen a girl.'

Eventually both his younger brother and mother died, and Joseph was left alone in the house.

People came to visit him from time to time, and Joseph would present them with souvenirs. The guests would carry their gifts home wrapped in handkerchiefs – a handful of sand, some dried flowers, shells from the nearby seashore. I received styrofoam flotsam, rocks, sea glass. But he also gave me valuable gifts. I remember, for example, a small work made with shells, which at the time I believe was worth about $3,000 (of course, it would be worth much more now). He gave me a number of such assemblages – one I remember included a collage with a cat superimposed on a cloud of cherry blossoms.

Many years later, when I was revisiting New York, an acquaintance told me that she knew the person to whom I had once sold a Cornell piece, signed 'To my darling Yayoi'. The acquaintance offered to negotiate for me if I wanted to buy it back. I had many works by Joseph, however, and declined. The piece in question was later sold at auction, and I was told that when the auctioneer read the inscription aloud, a murmur ran through the audience.

Whether because of his experience as a youth or because it was simply his nature, Joseph lived an incredibly frugal life. Sometimes he

would give me money, but would ask me to record and report in detail how much I spent on what, and when, and where. On the telephone he would lecture me not to buy things I did not need, or insist that I use the money only for painting materials and food. After he became rich, he bought some of my work. One, I remember, was a *Flower Net* on a pink background. He sometimes helped me sell things, too. He'd tell me, for example, that if I took such-and-such a painting to the Noah Goldowsky Gallery I might get X number of dollars for it. Beneath it all, he knew all about how the world worked. And all about men and women, too.

Our Fateful Last Conversation

—

In his later years Joseph underwent prostate surgery. While recuperating at his sister's house he became intent on seeing me and began another telephone blitz, begging me to visit. But I was now a major player in New York, and simply too busy to spend time with him. And, though it may have been cruel of me, I went ahead and said as much.

'Joseph, I'm tired. And it's your fault! I have my own work to do, and my own friends to see, and the Kusama Happening Company to run, and I'm busy. Stop ordering me around!'

At the time I was on friendly terms with Salvador Dalí and often drank with him at the St Regis hotel.

'When Dalí wants to see me,' I told Joseph, 'he sends his Rolls Royce for me. Shouldn't you show more respect for the love of your life?'

Less than five minutes after hanging up, I received a phone call from an elderly woman. 'Yayoi, I'm going to escort you to Joseph Cornell's place,' she said. Apparently Joseph had asked this woman, a collector of his works, to take me to him. She soon rolled up in a Mercedes, and off we went.

Joseph's sister's house was also on Long Island, but out in the middle of open farmland. It was scarcely more than a hut, and Joseph had been installed in a tiny room of his own. He was so happy to see me that tears ran down his cheeks. He took me in his arms and set me on the sofa next to his bed. And then, as always, we took off our clothes

and sketched each other. As we were sketching, rain began to fall, pattering on the galvanised iron roof. Joseph suggested we go outside. We put on our clothes and he led me out to the marsh. No one else was around. Beside the still waters, we kissed fiercely. Joseph pulled his thing out of his trousers and showed it to me. It was like a big, dessicated calzone. 'Please touch it,' he said, guiding my hand. The ridiculously large, round, thin-skinned lump of wrinkled flesh just lay there, indifferent to my touch and devoid of any sexual appeal whatsoever.

Ours was a platonic love, a pure and sacred kind of bond. Over the course of a relationship that lasted more than ten years, we never once had sex.

Any number of times I told myself I didn't want to see Joseph anymore, that I would not go to see him again, but all it ever took to weaken my resolve was for him to call and say my name: 'Yayoiii...'

I remember sitting on the sofa in Joseph's arms. He lifted me on to his lap and, as if playing with a kitten, put his hands around my neck and began to squeeze. It hurt, and I started trembling with genuine fear for my life. Then, suddenly, he let go, jumped to his feet, and scurried into the bathroom. And there he stayed for a long time. I began to worry that his heart had given out or something, so I went to the bathroom door and softly opened it. Joseph was on his knees, half-naked and praying fervently: 'Dear God, please forgive me!' He was clearly experiencing some sort of spiritual crisis and felt he needed to repent. I can still see the brilliant blue of the Long Island sky framed in that bathroom window.

Joseph was a devout Christian and had a tremendous complex about sex. From childhood on his mother had railed at him: 'Women are filthy!' 'You must never touch a woman!' I am certain that this is why that he suffered from impotence. All the time we were seeing each other he went to church every week. He often invited me to join him, but I was busy with my performances and painting and had no interest in church, so I always put him off.

When he returned from the hospital after surgery, Joseph seemed to lose confidence in his physical stamina. He was in his late sixties but looked about twenty years older. Compared to people like Isamu Noguchi or Louise Nevelson or Louise Bourgeois, who were in their eighties and still actively producing new works, he seemed shockingly spent.

Joseph kept saying he wanted to make a 'Yayoi Nude' box to wrap up his life. He begged me to send him some photos to use, but I was busy with my work and enterprises, and before I got around to it, death suddenly came calling. He suffered heart failure one night and was not

discovered until the following morning, lying on the floor where he had fallen. He died without ever regaining consciousness.

At the time, I was in Tokyo on business. Joseph had tried to discourage me from making the trip. 'You're going to Tokyo?' he said. 'Please don't do that, I beg you. Please stay in New York for your Joseph!' This was during what turned out to be our last, fateful conversation.

'You should work for another ten years, Joseph,' I said.

'I don't know if I'll live another ten years. But I want to make my Yayoi Box before I die. Hurry up and send me some photos.'

I did not like the photos he already had of me and kept meaning to have some better ones taken. But I failed to do it in time, and Joseph was still waiting for them when he died.

To Grow Closer to God

—

In death, Joseph's face looked as withered and exhausted as that of a ninety-year-old.

A number of art dealers sent telegrams of condolence to me in New York, and I was asked to attend the memorial ceremony at the Metropolitan Museum of Art. I also got a letter from a lawyer engaged by members of Joseph's family, asking about his estate. I wrote back to explain that Joseph had not entrusted any part of his estate to me. But he was no less generous than other men. I probably received more gifts from him than anyone else did, from artworks to boxes of sand.

I shall never forget that table in his kitchen, buried beneath layers of cheap vinyl and cotton tablecloths, some with things like 'WELCOME TO JAMAICA' printed on them. It was such a drab little house. I see him sitting in the corner of his dark room, curtains drawn, enduring his loneliness. I can still hear his gloomy voice on the telephone. And to think that this was a man who left behind about a hundred years' worth of work, all executed with incredible intricacy and care. He was not one to waste time drinking in bars. If he had any time to spare, he would search through thrift shops for old photos. Back in his workroom he would meticulously cut out those he liked, then paste them on to a board. His flat collages were all on boards about 7mm thick.

—

Once he was older and feebler, he hired as his assistant a young male sculptor to handle all the heavy work. It was probably from about this time that Joseph's hands began trembling.

I remember Joseph, turning up at my place with a paper bag full of pieces of wood and nails and sand and whatever else he had found along the way ... The looks he got from people who saw him as just another vagrant on the street ...

I learned many things from Joseph Cornell. He was a wonderful man, and his attitude as an artist was that of one offering his work to God. He created things not for himself or for fame or money, but in order to grow closer to God. There has never been anyone whose heart was purer. No matter how impoverished he may have been, I don't think he ever worried about making a living. Even when he had no money to get through the following day, he remained upright and balanced. Most people would panic in such a situation, but Joseph was not like most people. He believed that tomorrow would take care of itself.

I forget when it was exactly, but he once asked me what I thought about death. 'I never forget about death,' he said. 'It's just like going from this room into the next.'

I have the deepest respect for Joseph Cornell, and gratitude for all the ways he looked out for me. Of all my artist friends, he was the greatest. He wrote a large number of poems to me. This one was attached to a collage he gave me, with butterflies tied to strings:

FLY BACK TO ME
SPRING FLOWER
AND I SHALL TIE A STRING TO YOU
LIKE THIS BUTTERFLY

I TASTE SOME OF
THE DRINK IN YOUR
GLASS THAT YOU LEAVE
I DRINK TO YAYOI
NOW ----
I THINK OF MY PRINCESS

Donald Judd

Meeting Down
and Out

Let me begin with a brief profile: born in the United States in 1928, Donald Judd began writing art criticism while he was a graduate student at Columbia University, and helped to bring Yayoi Kusama to the attention of the world. Later he created his own works and is now considered to represent American Minimalism. When I met him he was a student of Meyer Shapiro in the Masters programme at Columbia. He was a well-groomed, handsome, and sincere young man.

Although he was from an affluent family, his father a top executive at Con Edison in New Jersey, Judd was determined to make it on his own in New York. While still a student, he worked part-time as an art critic for various big magazines. He came to see my exhibition at the Brata Gallery and recognised my talent. Moved by my pictures, he praised them highly in articles and essays that can still be found in his *Collected Works.* His criticism was extremely perceptive and fascinating, and he was a major force in making me into a star.

I often visited his apartment and sometimes stayed the night. Once, when I told him he should sculpt or paint, he said that in fact he was painting, and showed me some of his small action paintings – worlds away from the work for which he would later become famous. When he was looking to rent a loft downtown, I asked the secretary at the Sidney Janis Gallery if she knew of anywhere. She told me there were three floors open in the building next door. Judd liked the place as soon as he saw it, and leased the top floor; I moved into the floor below shortly after he had been awarded his degree in Philosophy at Columbia, and before I met Joseph Cornell. Neither of us had any money. Judd would go back to visit his family and return with home-made fruit pastries and other

treats which he would bring to my place to share with me. When I was out of money, I would go to Judd to borrow some, and when he was out of money, he would come to me. That was the sort of relationship we had.

Potatoes and onions were the cheapest vegetables, which meant that I made potato-and-onion dishes almost every day. But this became the cause of a bit of friction between us: I would cook with the windows open, and the fragrance wafted up to his study. He detested onions and finally lost his temper. 'Yayoi!' he shouted angrily down at me. 'How can I write with the smell of onions filling my room?'

We were both living in abject poverty. Judd had no money to buy art materials, so he would go to a nearby construction site, collect wood that was lying about, and carry it home. I would watch from the window and signal to him if the police came round. Sometimes, when I went with him to collect materials, a policeman would stroll past, and Judd and I would embrace and pretend to be making out. You could almost read the cop's thoughts as he walked on, his nose in the air: *I'm NYPD, baby. Can't be bothering myself about a little game of kissy-face.*

We called it 'collecting material', but in fact it was stealing, and if caught we would not have got away with just a slap on the wrist. But everyone lived like that in New York in those days. Even people like Louise Nevelson scavenged or 'liberated' materials for their work. Judd only began using tin in his works after he had made a little money and could afford to buy it. His earliest sculptures were made of scavenged wood.

The 'Minimalist' Leader

—

In the beginning Judd had no idea what sort of paintings he should do. He was, after all, a critic, not a painter. I may be the only one who ever saw his very first works, those little action paintings of his. They were terrible, and nothing like what one might imagine from his later work. Action painters were dashing lads who worked in a flamboyant way, and anyone in the market for paintings like that was sure to find things they wanted to buy. But these pictures of Judd's were unsaleable. He showed

me some twenty small paintings, each about 20cm square, and said they were the first he had ever painted. It was after he moved into the loft that his style began to transform into the sort of work for which he eventually made his name.

Having started as a critic, he was eloquent and well armed with theory but his painting skills were virtually non-existent, and it was difficult to tell what he was trying to do. I believe that it was because he did not have the basic techniques that he proceeded in the direction he did. He began making those minimalist boxes and objects after mentally squeezing concepts down to their elemental essence.

Once he became associated with the Leo Castelli Gallery, Judd grew famous before our very eyes. He was considered the pioneer and leader of Minimal art, but he disliked having his works described that way: he preferred the term 'Specific Object'. The essays he wrote at this time constituted a bible for followers of Minimalism.

Painters tend to view critics with a certain awe. That is why Judd could make a plain, unremarkable box, back it up with theory, challenge the world with it, and cause such a stir. Most truly talented artists are inarticulate with language. The greater the genius, the less eloquent he or she is likely to be. David Smith rarely spoke at all, and Joseph Cornell, though loquacious, never explained anything about his work. It is precisely because such people have difficulty talking about certain things that they express themselves in their art.

As a trained critic, Judd was thoroughly familiar with art history. When he created a work, I believe it was the result of a conscious decision about what would be successful. But there is no doubt that he kept evolving, and I admire the level his art attained.

When he was still single I introduced Judd to his girlfriend Doris. He subsequently met and married a beautiful fashion-model type, with whom he had two children. She, however, had an affair with an American man while on a trip to Switzerland. Judd was enraged, fuming that he would kill them both. After his divorce he swore that he would never marry again, decided to raise his children on his own, left New York and settled in Texas: 'There's nothing there,' he told me at the time. 'That's what I like about it.'

He bought some land with no other houses within sight, and constructed an amazing home and a museum in which a number of my works were displayed. He managed to incorporate his philosophy into his environment and lifestyle. The fixtures, fittings, and furniture were made for him, based on his own ideas and designs, and everything was in the same idiosyncratic style – even the way he lived.

Andy Warhol, David Smith, Herbert Read, and Adolph Gottlieb

—

My Good Rival, Andy

—

The building at 404 East 14th Street on the corner of Third Avenue, where I had my loft from 1965 to 1966, was also home to Claes Oldenburg, Larry Rivers, and John Chamberlin. On the first floor was a beauty parlour, and John Chamberlin and I shared a large studio space on the second floor. Oldenburg was on the third floor and Larry Rivers on the fourth. Rivers later bought the building for $200,000. Once Oldenburg got rich, he bought a house and moved out. I, for business reasons, moved in early 1967 to Greenwich Village, in the most happening part of downtown. I hung a sign at the entrance saying 'KUSAMA STUDIO'.

Years later, when I returned to New York, I revisited the building we had all lived in, only to find that the area had turned into a slum. The person who drove me there said that the real estate prices were falling at a rate of $5 a day. But it had been a charming neighbourhood when we lived there.

Andy Warhol was a close friend. His Factory was very near my studio, and our level of underground publicity was about the same. We were like rival gang leaders, enemies in the same boat. When he had just begun producing the sort of work that would later make him famous, he called me up and said he wanted to do a silkscreen of a certain photo of me reclining in the nude, covered in polka dots.

I was the queen bee in my studio, with attractive young gay men buzzing around me. A customer would choose one of the boys by number, then take him into one of the many small rooms we had partitioned off, to paint his naked body. I had a list of some four hundred boys, some of whom were paid a salary and others who would come when we called them.

—

Andy also gathered a lot of lovely models at his studio, and we competed for who could find the prettiest. Many of them worked at both of our studios, so there were often minor skirmishes. Andy, of course, was surrounded by young heiresses, dazzlingly beautiful girls with big eyes, and homosexual boys. I, for my part, managed such personnel as an investigative reporter for the New York Post and a gay boy who became the adopted son of a baron. James Golata, who had a postgraduate degree in philosophy from Columbia University, handled most of the day-to-day management for me.

When Lichtenstein produced his first comic-strip paintings, Andy's reaction was, 'Damn! He beat me to it!' It was exactly the sort of thing he had been planning to do next.

The Magnanimous Smith

—

David Smith often visited my studio. We became good friends after going to see the film version of Tanizaki's *The Key* together. From then on we frequently shared meals or went for walks.

Early on, Smith had worked as a welder at an automobile plant, and this had sparked his interest in art. Being an expert with the welding torch, he soon began creating powerful abstract sculptures made of steel and metal scrap. Like Joseph Cornell, Smith was a wonderful person. He was also manly and very magnanimous. He looked as if he had stepped right out of Hemingway's *The Old Man and the Sea.*

He was working class through and through, without even a whiff of the artiste about him, yet he was a fantastic sculptor. There are those who cultivate the air of an artist, but David Smith was not one of them – indeed, at first glance you would not have thought he worked in the arts at all. He had a big stomach, walked like a farmer, and chain-smoked. He also had a deep, chesty cough and a husky voice that seemed to issue directly from his ample belly. And he was always extremely considerate of me.

Smith was not a big talker, and I never heard him say much about himself. He quietly smoked his cigarettes and coughed. He always maintained a generous, easy-going manner but, unlike Cornell, rarely spoke unless spoken to: he was as taciturn as they come. And he was truly a good man, of the sort you could feel safe entrusting your very life to.

—

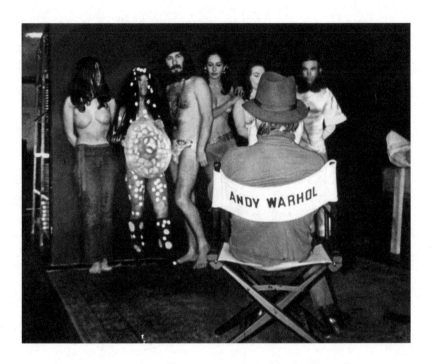

At Andy Warhol's studio
1968

The British Aristocrat Read

—

The most handsome of all the men I knew in the art world was the critic Sir Herbert Read. He had been knighted for services to literature in 1953 and lived in a stately home in the south of England, and was every inch the aristocrat.

In 1964, when Sir Herbert selected works by up-and-coming American artists for an exhibition called *The New Art,* he gave a talk saying that Yayoi Kusama was the best of them all. He reiterated this on television and radio as well, and it was all over the newspapers. I had been suffering from panic attacks and was unfortunately unable to attend his talk, but he was nonetheless kind enough to come to my solo show in New York.

During a trip to England in 1966 I visited Sir Herbert's estate. It had vast gardens, and a number of greenhouses where tomatoes, cucumbers, and other fruits and vegetables grew all year round. He showed me inside one where raspberries were being cultivated. I remember him asking me to send him some matsutake mushroom seeds from Japan, but to my shame I failed to meet his request. He even held a reception for me, with high-society guests, and I was photographed among earls and viscounts. The house was magnificent, with a ballroom complete with grand piano, which his wife played on occasion, and the estate employed secretaries, maids, servants, and gardeners. I remember that there were stables on the estate, with staff to look after the horses. Sir Herbert Read truly lived in the grand style of the English aristocracy. He was a man of unquestioned grace and distinction.

Gentle Adolph

—

I must also mention the painter Adolph Gottlieb, who visited my studio frequently and bought one of the Sex Compulsion chairs I kept there. He took me to Chinatown sometimes, and we also went to see films together. Adolph was a very gentle person. When he told me that a space was opening below his studio and asked whether I would like to move there, I seriously considered doing just that.

—

Part 5

Made in Japan

Worldwide Kusamania

1975 / 2002

The Gulf between Japan and New York

The sixteen years I lived in New York were very fruitful ones for me. With my paintings, sculptures, installations, and Happenings, I had managed to firmly establish Yayoi Kusama as a major and ever-growing presence in the world of avant-garde art. But of course the road had not been smooth. Every day had been a whirlwind of apprehension, excitement, anxiety, and struggle. I veered violently between two extremes: the sense of fulfilment an artist gets from creating, and the fierce inner tension that fuels the creativity.

The Happenings in particular had given me the opportunity to take my artistic activities out of the studio and expand them into new terrain, not only spatially but economically and creatively. The stars of the Happenings were the audience members, and the response was spontaneous and immediate. But the media, reporting on what I did, disseminated my message worldwide. Happenings did not end with the performances themselves, therefore, but continued to reverberate through the culture.

I resorted to any means necessary to capture my visual and illusory images and fix them in some sort of framework within which I could transform my ideological *Gestalten* into art for our time. Orgies, the sexual revolution, the gay revolution, unisex fashion – I embraced and addressed them all. I wrote musicals, too, one of which featured the eight-headed serpent of Japanese mythology as a sexual symbol and another which had *The Star-Spangled Banner* as its overture. I also created dresses made entirely of American flags.

In the course of giving form to my ideas, I managed to break many of society's rules, exposing myself to time in jail, trials, and pursuit by the FBI, living the real human drama of the 'Naked City'. Immersed in the uniquely feverish atmosphere of the New York I had gazed down upon from the roof of the Empire State Building, I was spellbound by the unfathomable cat's cradle of society and humanity, life and death. And I wanted to create my own future. I wanted to start a revolution,

using art to build the sort of society I myself envisioned.

At the same time, my work was a means to heal myself from psychosomatic illness. As a category of art, therefore, it did not relate to the social establishment or to fads. My art was not of the department-store window variety, where you are constantly changing the display to conform to the latest fashion – Action Painting today, Pop Art (or whatever) tomorrow.

I'm like a butterfly fluttering over hills and fields in search of a place to die, or a silkworm spinning silk, or a flower expressing its existence with a blush of red or purple. All I want is for human beings of every era to breathe the spirit and energy of their times and to face the future undaunted, with crimson flowers blooming. But throughout the history of my motherland, Japan – in each and every era – such blossoms have been regarded as the blooms of heresy. For some reason, the things I did or created were invariably met with misunderstanding and insinuations of scandal. The more serious I was about my work, the worse the friction with the world outside became.

There is no lack of suffering for one who takes an avant-garde stance in society. In Japan we are confronted by the inpenetrable wall of the system and its rules, the fallacies of collective society, distrust of politics, the chaos and loss of humanity engendered by war, the violence of the mass media, pollution of the environment, and on and on. The spiritual degeneration of mankind is forever trying to blot out the sun of our prospects.

Eventually my health began to deteriorate in New York, and in 1973 I returned to Japan for what I thought would be a temporary stay. I left my apartment as it was because I planned to fly back to New York after a brief convalescence. But in Tokyo my vision started to flicker and I began having hallucinations. I described for the doctor the swirling blue, red, and white configurations I was seeing, but he could not find the cause; failing to get any better I decided to stay in Japan. Because of this and other health problems, I ended up remaining in Tokyo, and in 1975 I entered the hospital in Shinjuku.

There was an enormous gulf between New York and Japan at the time, and that alone was enough to bring out my neurosis. Japanese society and the mass media were as conservative as ever, but there had been many changes. And it was only natural that these changes were more obvious to me, after an absence of so many years, than they were to people who had been living in Japan all along.

My impressions from travelling around cities in Europe and the USA were profoundly different from my impressions of Tokyo on my

—

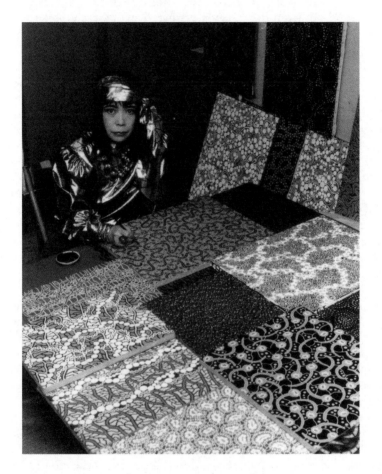

In my studio
Tokyo
1989

—

return. Shortly after I arrived I was climbing the wide stairs at a railway station into a descending tsunami of people. There was an almost eerie strangeness to this experience. When I looked closely at individuals in the wave, I was struck by their lack of individuality: they all acted and dressed the same and wore the same blank expressions, and they were nothing like the Japanese of my imagination. When, now and then, someone stood out from the cascading crowd, it was merely because they were imitating something they had seen in American or French fashion magazines. Exiting the station, these people headed for small apartment buildings along the crowded streets. In their little rooms, their TVs showed the same commercials. Their lifestyles and their ways of thinking had all become uniform. I could not stop thinking about this new lack of individuality in comparison to the old days. *What country is this?* I kept asking myself. It was not Italy or France or America, but neither was it Japan. My homeland had lost what was good about her traditions and was growing ugly as she modernised. This was not the way I would have wanted her to change.

Could anyone state categorically that progress and modernisation had brought happiness to the Japanese people? It seemed to me that, on the contrary, these things had brought only noise and pollution to the natural environment – and to people's hearts. But the citizenry were blind to this – they did not seem to know that their own hearts were in ruins.

I travelled the country looking for the tranquility of Japan, her beautiful scenery, her gentle human sensibilities, her simple and untainted ways, and the purity – in the best sense of the word – of her traditions. The result was that I felt all the more keenly how much she had lost in becoming an economic superpower.

I was a kind of Urashima Taro – a Japanese Rip van Winkle. I am sure that any number of Japanese intellectuals and social critics were saying similar things about our country in newspapers and on TV, but the situation only continued to worsen. It was painfully clear to me that Japanese politics acted for the benefit not of the people but of the ultra-wealthy and the politicians themselves. And what were the writers and artists, or the people themselves, doing about this? The crowds I saw walking about town appeared unaffected, expressionless even, in the midst of monumental crises, simply allowing themselves to be swept along on the rapids of recession, inflation, and incompetent governance.

I gave up on Tokyo and headed for my beloved home town. But when I visited a department store there to do a little shopping, what I saw made me wonder if I was really in Japan. In the clothing department,

all the signs were in English – either in the alphabet or spelled out phonetically in *katakana*. Even the words 'Made in China' were written in English, and rock music from New York blared over the sound system. I found this flood of foreign words, and the mountains of imported goods, nauseating. Why would anyone go to the trouble and expense of making signs in English just to sell clothing to women from the Japanese hinterland? Had the women there forgotten Japanese? Or was this a colony of the USA? I could only think that it all stemmed from a tremendous inferiority complex.

I turned on the TV, and out poured a deluge of English as Japanese products were advertised as if they were foreign goods. Having just returned after years of living in an English-speaking country, I was wearied and sickened by this phenomenon. Whenever an English word was dropped into a conversation, I would have to think for a moment to work out what the speaker was trying to say. It just made for a lot of wasted time. I felt disoriented in this new Japan, a country bumpkin fresh from New York.

I had returned to my home town for the first Obon Festival following my father's death. I visited his grave to pay my respects, and as I was taking my leave I glanced up and involuntarily cried out. Above the acacias around his tomb, cumulonimbus clouds billowed like gigantic cotton roses. I was deeply moved. It was as if I had touched the spirit of my departed father. After an absence of nearly two decades I was in my old home town, the place I had been seeing in my dreams. My father, who had been so healthy when I left, had grown old and died, and I would never see him again. A number of friends and relatives were no longer with us. I had not seen them since leaving for the USA, and now we were parted forever. Many of my classmates seemed to have completely disappeared.

The banks of the stream beside my old elementary school were now lined with concrete and all the fish were gone. The river where I once swam was opaque, polluted with waste from factories. Like Urashima Taro, when he returned from his long sojourn in the Dragon Palace, I suffered a sense of missing time and profound loneliness. My hometown had changed. New roads had encroached half-way up the once majestic mountains, leaving them painfully bare and scarred.

After seventeen years away, what I saw in Japan – both in Tokyo and in my home town – was disheartening.

The Mysterious
Snowscapes
of Home

As time went by, however, my grim first impression began to change. Spending the New Year in Matsumoto did much to alter my views. The snowy landscapes of Shinano (the old name for this part of the country), seen once again after so long, did not disappoint. I felt as if I were dreaming. I caught snowflakes in my hand and studied them closely. Vivid memories of more than twenty years before filled my mind, lifting my heart. It was almost as if my childhood had returned to me.

Travelling around the world, I had experienced winter in various countries. I remember, for example, the quiet snowscapes I saw in Germany. In Holland, a raging blizzard created finely textured scenery like the background in one of the great Pieter Bruegel the Elder's dramatic paintings. But the most beautiful of all snowscapes, the one that left the greatest impression on me, was in the mountains alongside Lake Como, near the Italian border with Switzerland. I had just finished a solo exhibition in Italy and set out from Milan to tour Europe by train. I sat in the observation car, drinking tea with lemon, as the snow-covered mountain scenery unfolded on either side. It was simply breathtaking.

I had driven across the Swiss Alps once before, with an Italian architect, under more stressful conditions. Starting in Amsterdam, we filled the car with avant-garde art in various cities we had passed through, selected for an exhibition in Italy. The show was a great success, with first-class artists participating, but preparing for it was a lot of work. We crossed the Alps in midwinter, in heavy snow. On one side of the road mountain peaks towered above us, and on the other side were sheer drops into what looked like bottomless chasms. At the wheel was my companion, a spirited woman who had already worked on many big projects and was making a name for herself in a field still dominated by men.

We sang at the tops of our voices as we drove across Europe. I do not know how fast we were going, but we were stopped by the police a number of times. Not satisfied with simply blasting rock music on the radio, the driver insisted that we sing or talk non-stop: unless we

conversed constantly, she warned, she might fall asleep at the wheel. Traversing the twisting mountain roads at reckless speeds, we drank coffee from a thermos and chatted loudly about art and literature and other things. I too was sleepy, but whenever I lapsed into silence, the architect would scare me awake: 'Yayoiii! I can hardly keep my eyes open. Keep talking! You don't want me to drive off the cliff, do you?' Plunging into the abyss below would have been the end. It was night time and snow was swirling in our headlights, our only illumination. There were virtually no other cars on the road, and all around us was darkness. We kept a revolver hidden in the car and agreed that we would use it, if necessary, to kill any attackers.

As our headlights swept over one spectacular ravine after another, I found myself thinking of Shinano, the 'Switzerland of Japan'. *Right now it's winter in my home province too*, I thought. As I wondered how my friends and family were getting on, I tried to call up childhood images of the snowy Japan Alps. But my life had been so filled with frenetic activity ever since I left Matsumoto that it was difficult for me even to summon nostalgia for the tranquility of my home town. I had been dashing about the world all this time without ever finding a chance to travel to Japan. Airplanes, trains, ships, and cars had been carrying me to appearances at museums, exhibitions, art schools, public halls, universities, and TV studios around the globe. Yet I had never imagined that one day I would find myself back in Matsumoto, sitting with family and friends around the hearth, eating traditional New Year's treats and gazing out at Mount Hachibuse. This, for me, was a true Happening.

My feelings had been somewhat mixed on arriving at Matsumoto Station, where I had begun my journey so long ago. This was not at all the same snow-covered, mysterious home town I had carried in my heart all those years. I felt lost, like a tourist stranded in rush-hour Tokyo. The progress of my home town and its rapid growth into a city was gratifying in one sense. But it gave me pause to realise that if I wanted to find the beauty of old Shinano, I would have to go in search of it.

Even with this emptiness in my heart, however, when I saw the resplendent, silvery flakes falling from heaven and accumulating on the ground, I knew that this was indeed the same home I had recalled while driving across the Swiss Alps. Moved by the beauty around me, I thought, *Ah, the home of my heart is a mystical place after all!*

I wandered through meadows and over smooth-stoned river banks in search of winter, composing a poem about the highlands, watching snow fall from a marble-coloured sky, and gazing at mountains blurred in a powdery silver haze. This was quite different from the cacophonous

metropolis of New York – the symbol and centre of American civilisation – where life was lived in a glowing crucible of cultures.

Anything you wanted was in New York. At one point I saw plays on an almost nightly basis, from a stage production of Dostoevsky's *The Idiot* to works by Arthur Miller and Truman Capote, to performances at beatnik dives in Greenwich Village. On Broadway I saw *Butterflies Are Free* starring Gloria Swanson when she was nearly eighty. I was in awe of the legendary actress's die-hard thespian spirit, and the experience only fuelled my enthusiasm for the theatre. A musical based on the life of French fashion legend Coco Chanel also left a big impression on me.

I went to museums and galleries, studying everything from Egyptian art to Art Nouveau and American Arts and Crafts, in a fever of research. My desire for learning also led me to the New York Public Library on Fifth Avenue and the libraries at Columbia University, where I borrowed the classics from Greek myths to Shakespeare. I would carry these heavy tomes back on the Subway to my studio, where I would spend all night poring over them. When dawn broke I would think, 'Morning already?' and go to the kitchen for a very welcome cup of coffee.

I staged one of the musicals I had written and produced as part of a Happening in front of an audience of four thousand at the Fillmore East in the East Village. The Fillmore, where such stars as B.B. King and Mick Jagger had performed, was one of the three largest theatres in New York. On opening night, unfortunately, I came down with a raging fever, and when the show finally ended I nearly collapsed backstage.

I was also invited to art festivals at educational institutions such as New York University and the New School of Social Research, where I put on Happenings and avant-garde fashion shows and plays to introduce students to my holistic ideas of art. A number of students regularly came to my office to borrow materials. They were enrolled in art departments at NYU and other universities, young people who were full of the desire to learn and intended to become teachers. I tailored my Happenings both artistically and philosophically for such students.

Meanwhile, the weekly magazines in Japan, with their reliably contrary view of my art, had been reporting falsehoods and gossip about me that they had gleaned from Japanese artists in New York. Members of the Matsumoto First Girls' School Alumnae Association, having read such nonsense, removed my name from their list. When I returned to my home town, I discovered from my former classmates that they had been asked to sign a petition to have my name removed. I was dumbstruck by such unbelievable provincialism. Yet I know this sort of thing can happen at any time. It is the fate an avant-garde artist must bear.

The Existence
of Superior Artists

—

In New York I was so busy with my painting and projects that I never had time to enjoy the snowscape of winter. I was forever rushing to keep up with my work and my many international exhibitions. For years I had hoped to view the Japanese cherry trees in bloom at the Brooklyn Botanic Garden and quietly reminisce about spring back home, but I never did manage to find the time. People called me an art maniac and a workaholic. When you are engrossed in art, the days of your life just seem to fly by.

Because I was firmly in the advance guard – doing work that was decades ahead of its time – people often misunderstood me. A large number of Japanese artists came to New York to live or to exhibit, but some of them brought with them a peculiarly Japanese 'island mentality'. They thought nothing of causing trouble for other artists by telling exaggerated, disparaging tales about them to museum officials and journalists visiting from home. This, of course, was because they had no confidence in their own art and because of their selfish concern for personal gain. They were intent on promoting themselves alone and spreading falsehoods about other Japanese artists residing in New York. These were Japanese men doing big, macho stone sculptures and yet, laughably enough, gossiping like old ladies around the well.

In contrast to this aspect of the Japanese character, so evident to me in New York, was the maturity of American artists as human beings and members of society. Artists raised on the vast continent of North America had a bigheartedness about them that was very appealing. In Canada and Europe as well as the USA I met hundreds of artists who helped and encouraged one another: their mutual respect always came first. And this attitude contributed to each individual's own spiritual freedom and liberation.

Meeting so many good artists and seeing so much excellent art was what I enjoyed most and found most interesting when travelling the world. In places like Switzerland, Germany, Holland, Italy, and the USA

there were countless artists doing great work – some of them near the end of their life and yet virtually unknown. In small villages in the mountains of Switzerland, in ancient towns in Italy, on the outskirts of Paris, I visited the studios of artists both nameless and world-famous. I watched them at work and shared meals with them, and I will never forget their kindness and friendship.

Now, sitting by the fireside in my own family home, I was dismayed at the artwork that hung on the walls. There were sketches that were not even up to the level of student work overseas, and landscapes more incompetent than the casual daubings of third-rate hacks. In terms of career, name recognition, talent, or originality, the local artists responsible for these works were close to zero by any measure, but over the course the years my mother had been pressured into buying this junk at outrageously inflated prices. Having seen countless landscapes and still lifes by top-ranking artists from around the world, I found myself calculating how many wonderful works by this or that artist in Switzerland or New York she could have bought with the same amount of money. I myself had collected works by such artists as the legendary Piero Manzoni of Italy, the epoch-making American Joseph Cornell, the historic Yves Klein, and the great Lucio Fontana, who went on to conquer the European art world – all for less than the prices of some of the sculptures and paintings that had been foisted upon my family in Matsumoto. Most of the works in my collection are by artists whose names will go down in history. I have bought major pieces by them – pieces you can find in books of their work – for modest sums of money. Among these are both figurative landscapes and abstracts: and long experience has trained my eye.

Be that as it may, it did me a lot of good to see the snowy mountains of my home town once again, after nearly twenty years. Corrupted by civilisation though the city was, it was still possible to discover heart-stopping beauty in the hills and fields of Matsumoto: meadow grasses that waved and rippled in the wind, the broken, skeletal forms of withered weeds, and, most fascinating of all, the movement of space itself in free-flowing transformations of drifting snow, the fathomless glistening of the garden at night.

Winter in Shinano is beautiful. Dawn illuminates a panorama of silver-white snow and outlines the mountain ridges in pale purple. Distant cedar groves and pine forests draped in white appear as brush-strokes on a silver picture scroll. When the rising sun emerges from behind the mountains, the snow shimmers and the light separates into billions of particles penetrating every direction. Slowly the blue sky turns

even bluer, and then infinitely blue, a blue that seems to pierce the depths of the cosmos.

In spring, row after row of cherry trees burst into full bloom and then unleash a blizzard of petals. As you walk beneath the branches, the petals land on your cheeks as lightly as snowflakes. Summer is beautiful too. White clouds in the sky race quietly over the surfaces of streams, and the scales of little fish flash in the sunlight. Clouds swell and billow overhead like giant cotton roses bursting into bloom. In autumn, the receding tiers of mountain ranges are laced with threads of gold and silver. The lacquer-red of the leaves enfolding the mountains, so bright as to almost hurt the eyes, fades slowly to yellow. The sight of the colours gradually settling as the sun sinks over the western mountains is worth a thousand pieces of gold.

Nature never grows old, endlessly unfurling her infinite beauty through the seasons. And the landscape of Shinano is beyond compare. I was so lucky to be able to call this place home! And even greater than Shinano's natural beauty is the beauty in the hearts of her people. The warmth and congeniality of old friends and acquaintances soothed my spirit more than I can say.

Contrary to my expectations – having turned my back on my town to go to America – I was treated to a warm welcome by both the natural world and the people I had left behind. But no one knew better than I that I was not one to stay there, wrapped in that warmth, forever.

Rediscovering
the Japanese
Language

I began working at a furious pace as soon as I got back to Tokyo. But my Tokyo was rather different from the Tokyo experienced by most people. I moved into an open ward at the hospital where I have remained ever since. Across the street from the hospital I built a studio, and this is where I work each day, commuting back and forth between the two buildings.

Life in the hospital follows a fixed schedule. I retire at nine o'clock at night and wake up the next morning in time for a blood test at seven. At ten o'clock each morning I go to my studio and work until six or seven in the evening. In the evening, I write. These days I am able to concentrate fully on my work, with the result that since moving to Tokyo I have been extremely prolific.

In December 1975 I held my first solo show since my return to Japan, *Message of Death from Hades*, at the Nishimura Gallery in Tokyo. It featured a large number of collages.

Even before I left Matsumoto for the USA I had been fascinated by collage and assemblage, pasting together bits of shredded paper or filling boxes with stones I had collected from the wide, stony bank of the river behind our house. As I child I would go there to play, stacking rocks or counting the numberless stones one by one. Long before starting to create artworks I had been in the thrall of a vision of 'repetition' which, along with 'multiplication', was to become the foundation of my art.

In 1975 I was making collages, and in 1979 I began producing prints. I had never been interested in the print as a medium of expression until I met the printer Tokuzo Okabe. I made silkscreens at first, and I have continued to produce prints ever since. In 1984 I began working on lithographs and etchings in collaboration with the printer Kihachi Kimura.

In 1995 I printed a predominantly autobiographical series of etchings. One, titled *Commemorative Photo Shoot*, was an exercise in pure self-expression: it pictured fourteen women standing in a group – all of them me.

—

Thus I continue to take on the challenge of one new medium after another. And by making these media my own I continue to expand the reach and scope of my art.

Another facet of my activities became public in 1978, when my debut novel *Manhattan Suicide Addict* was published by Kosakusha. I had started drawing before I was ten, but I had been writing since I was at elementary school, winning awards in prefectural essay contests. In my late teens and early twenties I wrote a great number of stories and poems, and even vacillated as to whether to become an artist or a writer.

For me, self-expression through art and self-expression through writing are essentially the same thing. Both offer methods of discovering new territories of the mind. And with both, I always aim to be in the vanguard.

Since moving to the USA in 1957 I had fought my way through with my art, as a standard bearer for the international avant-garde, dashing about the globe; during that time, of course, I communicated predominantly in English, did most of my thinking in English, and even muttered to myself in English. Then, returning to Japan, I met up again with my native language. By writing novels and poems in Japanese, I was able to shine light on a different facet of myself, one that I could not reach with plastic arts. This allowed me to cultivate new spheres of self and reorient my soul.

The machinery of the sky that confounds us on earth with endless transformations of clouds in the light of dawn does not compare to the extraordinary tenacity of human beings, the way of human life, the presentiment of approaching death, the existence of love, the brilliant corruscations of light and the dark scars of our lives, to say nothing of the incomprehensible form of the cosmos and the overwhelming mysteries of space, time, distance. What is it that towers in the background, looming over all this? I wanted to express my powerful yearning for that unknown something and to create a sublation of spirit with my rediscovered first language.

In my writing, as with my artwork, the images just keep bubbling up and spilling out, one after another. I have written as many as a hundred pages in a day. In *Manhattan Suicide Addict* I included a parody of the classic *Hundred Poems by a Hundred Poets,* which I wrote in just two days. I dashed out the novel itself in three weeks, in a burst of manic energy, and it was published without any alterations. The book includes a foreword by Sir Herbert Read and an afterword by the poet and art critic Shuzo Takiguchi. The following is an excerpt from Takiguchi's essay, 'Our Faerie Spirit Forever':

—

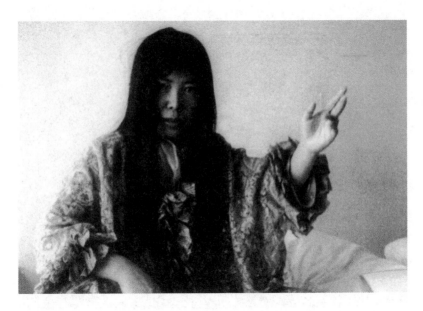

In my room
Tokyo
C.1975

—

—

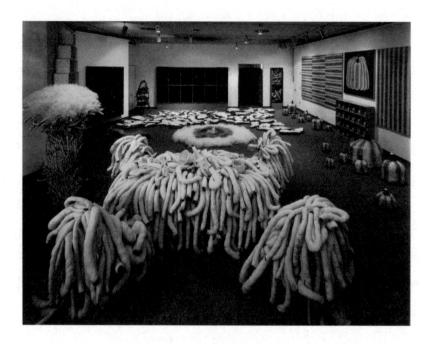

***Yayoi Kusama* exhibition**
Fuji Television Gallery, Tokyo
1984

—

After long wanderings, you have once again manifested before us. It's not a dream. Or, if it is, it's a dream that came true and left incontrovertible proof of itself behind...

Expression is essentially something that is hurled out into the world from within, something that emerges from the individual and asserts its existence in the world. Whatever the subjective raison d'être for what Yayoi Kusama expresses, objectively speaking its existence is fully justified – though it's not necessarily there to make us happy. Isn't it ironic that Kusama's work was recognized here only after achieving proper evaluation overseas? Even if it could not have happened any other way...

Faerie spirits? If they exist, it isn't by choice. Born on this earth, they are undoubtedly seeking the right to exist in this world. But why as faeries? Surely it's because they're destined to live in the space between subjectivity and objectivity. The existence of the fluid yet fixed signifier 'Art' — doesn't it speak of the fact that this sort of relationship is always wafting in the air around us? Our faerie sprit forever!

In 1983 my novella _The Hustlers Grotto of Christopher Street_ won the Tenth Literary Award for New Writers from the monthly magazine _Yasei Jidai._ The judges were the noted novelists Masahiro Mita, Michitsuna Takahashi, Teru Miyamoto, Ryu Murakami, and Kenji Nakagami, all five of whom gave my work top marks. I subsequently developed personal friendships with Ryu Murakami and Kenji Nakagami. In an interview, Murakami called me a 'genius' and said, 'the harrowing psychological tension of Yayoi Kusama's novels, the descriptions of life on the border between the everyday world and an extremely strange one, gives them a boundless reality. In this respect she has no peers.' My association with Ryu Murakami resulted in my appearing in the well-known 1991 film he wrote and directed, _Topaz_ (also known as _Tokyo Decadence_).

The Yasei Jidai prize marked the formal debut of Yayoi Kusama, novelist. My fever for writing only increased, and I wrote and published novels and poems in rapid succession.

Creating art and writing novels and poems are simply different roads I have chosen in my search for truth.

For Someone
a Hundred Years
from Now

I have been painting, sculpting, and writing for as long as I can remember. But to tell the truth, to this day I do not feel that I have 'made it' as an artist. All of my works are steps on my journey, a struggle for truth that I have waged with pen, canvas, and materials. Overhead is a distant, radiant star, and the more I stretch to reach it, the further it recedes. But by the power of my spirit and my single-hearted pursuit of the path, I have clawed my way through the labyrinthine confusion of the world of people in an unstinting effort to approach even one step closer to the realm of the soul.

If you think about it, there is nothing inherently distinguished about the occupation of artist – or politician, say, or doctor. I was once moved by the story of a disabled person in an institution who, after working hard all day, was able finally to screw in three little screws, whereupon her eyes lit up with the certainty that her life was a gift from heaven.

An artist is by no means superior to others just by virtue of making art. Whether you are a labourer, farmer, janitor, artist, politician, or doctor, if you have managed in the midst of a society awash with lies and madness to get one step closer to the awe-inspiring brilliance of your own life, the footprint you leave behind is that of someone who has truly lived as a human being.

Today, many people take the path of gluttony, or lust, or greed, flailing and floundering as they vie for worldly fame. In such a society, seekers of truth find that their burden is great and the road steep and hard. But that is all the more reason for us to seek a rosier future for the soul.

Many people seem to imagine that Vincent van Gogh must have been great because his paintings now fetch enormously high prices, or because he was mentally ill. But such people have not really seen van Gogh. Japanese psychiatrists, meanwhile, tend to argue over whether he suffered from schizophrenia or epilepsy or some other malady. My view

is that in spite of whatever illness he may have had, van Gogh's art overflows with humanity, tenacious beauty, and the search for truth. His real greatness lies in these qualities, and in his fiery and passionate approach to life.

For an aspiring artist like myself, to triumph over an unjust environment is to triumph over the pain of feeling cornered and trapped. I see it as a trial or test attendant upon having been born a human being, which is why I continue to fight with every fibre of my being. This is my own peculiar karma and destiny in this world.

Revelations from above have made it clear to me that my life is also a divine gift. Hardship and trouble concern me every day. And every minute of every day, as the years go by, I am conscious of death.

I intend to intensify further my search for the truth that leads to the light. I want to lift my heart towards a brighter future, with a sense of reverence for human beings, asserting that we are much more than just wretched insects in an unimaginably vast universe. I have chosen art as the means to accomplish this. It is a lifelong task. And even if only one person in the next hundred years were to comprehend what is in my heart, I would continue to create art for the sake of that one individual.

In December 1983, nine years after the death of my father, Kamon, my mother, Shige, passed away. She was a poet and a calligrapher all her life. As I was sorting through her papers, I found these poems.

After so many deaths, this year too
draws to a close
with leopard plants blooming

Sunlight's warmth
summoning spring
along the glistering riverbank

Reverberating in the invalid's
sleepless night
the receding sound of a train

I transcribed these three poems of hers in a postscript to my novel *Love Suicide at Sakuragazuka*. A thousand volumes would not be enough to record my feelings for my mother and father, but with this gesture I wanted fix one small point of light in the galaxy of memories I have of them.

NOW THAT YOU'VE DIED
for my late parents
—

Now that you've died
your soul, above cotton-rose clouds
mingles with powdered rainbow light
and disappears forever

And you and I
at the end of our endless battles
of love and hatred
have parted
never to meet again

To me, born a child of people
parting is like quiet footsteps
on the path of flowers

Beyond the clouds of sunset
a soundless hush

I have borne my love and hatred for my parents – an ocean of conflicting emotions – throughout my life, but now I have begun to see things somewhat differently. It was my mother and father who made it possible for me to live to this age, who taught me about the light and the darkness of life and death and about the contrivances of society to design and define time in this world, who exposed me to spectacular fight scenes and inspired in me a desire to find real wisdom and truth as a human being. For my parents, who gave me life, I now have nothing but heartfelt gratitude and the greatest love and respect.

In the 1970s, members of the Japanese mass media labelled me 'The Queen of Scandal', 'The Shameless Artist', and 'The Naked Provocateur'. But such trivial and superficial criticisms began to fade in the early 1980s. By this time, naked Happenings and body painting were commonplace around the world.

My first-ever retrospective exhibition, which opened in March 1987 at the Kitakyushu Municipal Museum of Art, held a great deal of meaning for me. The seventy-nine works I selected covered a period of forty years – the earliest made in 1948, when I was nineteen years old – and comprised forty-six flat works (including watercolours, collages, and tableaux), and thirty-three three-dimensional pieces.

To show in one place at one time works covering such a long period and wide range of genres, emphasising the variety of expressive forms available to me, was tremendously helpful in promoting a better understanding of my art. Even the Japanese mass media, which are so resistant to the avant-garde, finally made an attempt to revise fundamentally their assessment of me. And thanks to coverage on Fuji TV, NHK, TV Tokyo, and other networks, familiarity with my work increased dramatically.

Something similar was happening on an international level as well. In September 1989 the inaugural exhibition for the Center for International Contemporary Art (CICA) in New York was *Yayoi Kusama: A Retrospective.* This exhibition marked a serious re-evaluation of 'the world of Kusama's art'.

The opening of CICA was delayed on this occasion, primarily because I am an incorrigible squirrel. The CICA staff took a great interest in the letters, memos, and mementos that I had stored away over the years, and sorting and cataloguing these proved an operation of such complexity that it could not be finished in time for the scheduled opening. The result, however, was that we were able to exhibit a veritable cornucopia of material. Even though I am in disagreement with many statements in my personal history as chronicled by Alexandra Munroe

and Bhupendra Karia, it was gratifying to see so many items displayed publicly for the first time – including correspondence from Georgia O'Keeffe and love letters from among the many thousands I had received from Joseph Cornell. The retrospective was widely praised, with reviewers saying that it was not only a first-rate source of material for the study of Yayoi Kusama, but a precious resource for post-war American art in general.

The retrospective ran from September to January and attracted a large number of visitors. The magazine *Art in America* even featured me in a cover story – the first-ever for a Japanese artist.

In order to attend the opening, I returned to New York for the first time in sixteen years, and found that it had changed. It was no longer the city that had been the stage for my spectacular activities all those years ago. Drug use was rife, slums had become widespread, and I could not find any of the old vitality in the place.

But what surprised me most was what I discovered in the museums. Things had not progressed at all from the time I had lived there. Warhol, Lichtenstein, Jim Dine – everyone had continued doing the same thing for more than forty years. The only difference was that now they were recognised. I was stunned by this apparent complacency. The stars of the New York art scene were promoted heavily in Japan, but it was plain that there was nothing behind the image. No new art was to be found there.

Still, it was New York, and even if the apple was beginning to rot, it was nevertheless a very fine apple. The support for culture there was at least ten times what it was back home, and the contrast made it painfully clear to me just how little sustenance contemporary art received in Japan.

Encouraging
Culture at Home

I cannot help feeling that Japan is like a village of wealthy country bumpkins. There is no comparison between New York and Tokyo in terms of freedom and originality. In Tokyo one is bound by the vertical and horizontal axes of Japanese society, and relations between people tend not to be very frank or straightforward. New York has a broadmindedness about it that Tokyo lacks, which is why everyone wants to go there. It was New York's openness that nurtured my creative powers, at a time when such things as performance art and the underground cinema were flourishing there.

These days foreign art dealers and artists frequently come to Japan. Many of them are people I know from my days in New York, and I often meet with them when they are in Tokyo.

'Why is everyone stampeding to Japan?' I ask them. 'Is it because capitalism is dying in New York and people are too poor to buy your paintings there?'

'No, it's not that,' they all tell me. 'It's because in Japan we can inflate the prices of our work by a factor of ten. It's too tempting to pass up!'

So, in the final analysis, the Japanese are being played for fools. Since the bubble years, the rich have gone to Hawaii and parted with stacks of dollars to buy up golf courses, or paid ten times the market price for a castle in Europe that has no electricity or flushing toilets. People have more money than they know what to do with, yet all they can think about is making more money – which only impoverishes them in heart and spirit.

The word abroad is that if the buyer had not been Japanese, van Gogh's *Sunflowers* would have sold for a third of what it went for in that famous auction in the late 1980s. It is common knowledge that when Japanese buyers are known to be interested in a piece, the sellers conspire with ringers in the audience to bid up the price. I cannot help thinking that if these Japanese art lovers have that kind of money to throw around,

they should use it to establish a system for boosting culture and art at home. The reason why foreign collectors are now selling their Impressionist paintings in Japan at such outlandish prices is not that they are in need of money, but that they want to use the money to cultivate and promote contemporary art in their own countries.

In Japan, avant-garde artists are in the most unfortunate position of all. The lunacy of fawning over mediocre foreign artists and showering them with millions is bound to be dispiriting to young native artists looking to get something started. Anywhere else in the world it would be unthinkable for artists to sell their works for ten times the price they could get in their own countries, simply because of the colour of their eyes and hair – and yet this is still the norm in Japan. We have to speak out more vociferously against such silliness.

One point I wish to make is that there are very few major art dealers in Japan nurturing the culture of their own nation. They care only about the immediate business of selling artworks, and virtually none of them do anything to help develop groundbreaking new artists. But it is not only the dealers whose efforts are devoted solely to making money. I would like to see the museums, the dealers, and the staff of the art magazines do more to promote their own culture, putting their own necks on the line for it.

The system controlling the art world in Japan is a pre-modern relic, and people with old-fashioned minds are squashing the unique ideas and liberating ingenuity of young artists. Among all the advanced nations, Japan lags furthest behind in contemporary literature and art. But before contemporary art can progress, there needs to be an opening of the heart. That is why Japan is such infertile ground for cultivating contemporary artists, and why our art is still under the colonial domination of foreign lands. There are too many Japanese artists who simply imitate the styles of pictures that are selling well overseas.

It is not simply a question of finding talented people but of nurturing that talent, and artists are nurtured by their environment. Something must be done, but the people in power, whether in the corporations or the museums, are too hard-headed, and politicians too poor in spirit. These people are motivated by a self-serving, narrow sort of nationalism and do not seriously think about cultivating new ideas. The Japanese have plenty of money but no corresponding modern culture or ideology.

Young people who aspire to be artists and want to try new things are supplied with everything they need in terms of materials and technology – video and so forth – but are ideologically impoverished. There

are no platforms for a young artist to get a foothold with a solo show or two, and few critics who will write about them and assess their work reliably. It is difficult to nurture artists in circumstances like this, and fresh talent becomes discouraged. The system not only makes it difficult for artists to grow, but actually causes them to lose heart.

'I'm impressed by your paintings. I'm rooting for you, so hang in there.' How many of us approach young artists with such words of encouragement? Instead, it is 'This picture isn't marketable' or 'Without a gallery behind you, you'll never get anywhere'. I cannot help but feel that Japan is twisted and primitive. It is not a matter of simply lagging somewhat behind other nations culturally – I would say we are at best about one step out of the jungle.

I experienced culture shock when I returned to Japan. Because the nation had become an economic superpower while I was overseas, I had expected to find a certain cutting-edge, modern spirit, and to find that democracy had developed in concert with the nation's growth. But the reality was very different. I was not at all certain that the works I created would speak to people in a society like this.

I had no choice but to follow my own path, however. I decided that I would continue asserting my beliefs until I died. Even if it were to bring only sadness in the midst of such desolation, all I could do was express my thoughts through my art, putting my very life on the line. And if, a hundred years from now, someone were to see my art and think, 'Kusama did some really good work', I would be satisfied. Art, for me, is a creed.

The 'Kusama Renaissance'

In 1993 I officially represented Japan at the Forty-fifth Venice Biennale. This was some twenty-seven years after the Thirty-third Biennale, in which I had participated in a way some described as 'guerrilla fashion'. This time I had received a bona fide invitation.

In 1966, after speaking to the chairman of the Biennale committee, I had been allotted a space to install *Narcissus Garden*. I went straight from that meeting to a factory in Florence to order my mirror balls. I had no money at the time, but my friend Lucio Fontana was kind enough to cover the cost. It has always bothered me that I never got around to repaying him before he died. Now, twenty-seven years later, I was the official Japanese representative. I exhibited twenty works, including *Mirror Room, Self-Obliteration, Shooting Stars, Infinity Flower Petals, Pink Boat*, and an installation of giant pumpkins.

This was effectively the first solo exhibition ever at the Japanese Pavilion. In 1976 the pavilion had been given over entirely to the photographs of Kishin Shinoyama, but the architect Arata Isozaki was in charge of designing the show, so that it was actually a collaboration between the two. I was the first to have the whole space entirely to myself.

Professor Akira Tatehata of the Tama Art University, who acted as the Japanese Commissioner, wrote an essay for the catalogue titled 'Magnificent Obsession':

> *Kusama's achievement was wide-ranging and unique, and it can be approached from many different directions. She has been seen as a pioneer at the forefront of the post-war avant-garde and a producer of a pathological art brut. Her work has been seen as reflective of political and social realities and reevaluated in terms of feminist and formalist criteria. This exhibition makes it clear that she has continued working in the same way without let-up and expanding the scale of the work so that it overwhelms the viewer. The pure*

light that appeared to her in the nineties provides an image
of another world which can only be described as disquieting
and mysterious and intensely fascinating.

The magazine *Bijutsu Techo* devoted a special issue devoted to
'Yayoi Kusama: The Origin and Development of Obsessional Art'. Here
the critic Atsushi Tanikawa began a long thesis entitled 'The Phantom
Spirit of Propagation' with the words:

Yayoi Kusama has been chosen to represent Japan at the
Venice Biennale. I can't help wondering, Why now? – while
at the same time thinking, Well, it's about time. It might
be considered an unusual choice, but then again, maybe it's
only to be expected. In any case, this much is certain: the
selection of Kusama is a happy and extremely gratifying
development. Surely it doesn't mean that there are no other
artists now working in Japan whose impact makes them
worthy of the Venice Biennale, but what is significant is that
an incorrigibly free and proudly independent artist has been
elevated to the status of Japan's lone official representative.
Times have certainly changed.
(Atsushi Tanikawa, *Bijutsu Techo*, June 1993)

My credo dictates that I continually expand and develop the world
of my art, and in 1994 I began to work on large-scale outdoor sculptures.
At the Fukuoka Art Museum, the Fukuoka Education Center, and the
Benesse Art Site Naoshima, among other locations, I installed *Pumpkin,*
Three Hats, and other giant pieces. At the Kirishima Open-Air Museum
in Kyushu I installed *Flowers of Shangri-la* and *High Heel,* both assum-
ing dimensions of many metres. And at the Obayashi Corporation's
headquarters in Tokyo I installed a piece that measured 10 x 7m, made
of layers of glass on which were engraved identical infinity nets. The
overall pattern shifted and transformed according to the angle from
which the piece was viewed, creating a true 'infinity'.

In Lisbon I produced a mural for the Subway Orient Station,
commemorating Expo '98. *The Bottom of the Sea* consisted of two
expanses of painted porcelain, one on either side of the arrival–departure
corridor.

Meanwhile I had also been holding solo exhibitions at various
venues in Japan and abroad. Among them, my show at the Paula Cooper
Gallery in New York, in May of 1996, *Yayoi Kusama: The 1950s and*

1960s, received rave reviews, and the International Association of Art Critics (AICA) honoured this exhibition as Best Gallery Show of 1995–6. My exhibition at the Robert Miller Gallery that same year also won an AICA award. A review in *Time Out* said that 'Kusama has kept out of sight, ensconced in her own infinite world, but now she's back to reclaim her rightful place in the history of postmodernism'. And Roberta Smith, writing in the *New York Times,* described the Cooper show as 'an amazing mix of references and sources, given the continuity of Ms Kusama's style. Her accumulating technique has enabled her to flit among media and cultures with the greatest of ease, mixing East and West, insider and outsider in the process.'

But the biggest highlight came in March 1998, when *Love Forever: Yayoi Kusama 1958–1968* opened at the Los Angeles County Museum of Art. This grand retrospective cemented the reassessment of Kusama as a major avant-garde artist. It included some eighty pieces and had taken five years to compile.

Love Forever was a travelling exhibition. It stayed for three full months at each venue, and all the shows were well attended. After Los Angeles it opened in July at the Museum of Modern Art in New York, and then in December at the Walker Art Center in Minneapolis. In April 1999 it made its triumphal return to Japan at the newly constructed Museum of Contemporary Art in Tokyo. By this time the exhibition had expanded to include works covering a period of seventeen years, from 1957 to 1975.

After seeing the retrospective in Tokyo, the young philosopher Akira Asada penned a most encouraging essay entitled 'The Victory of Yayoi Kusama':

> *Such energy! Seeing the Yayoi Kusama retrospective at the Museum of Contemporary Art Tokyo, I felt once again overwhelmed as the polka-dotted forms with their vivid colours and the phallus-shaped objets spread and proliferated endlessly before me. This exhibition is indeed a monument to the dazzling victory of one lone woman who has battled mental illness all her life and managed to transform that bitter struggle into magnificent art...*
>
> *She turned the tables on a life-threatening repetition compulsion, converting it into art and attempting thereby to effect a self-cure. But that is a process that doesn't end with a single victory: Yayoi Kusama has had to return incessantly to the starting point and repeat her bitter struggle.*

—

*She came back to Japan in 1973 and entered a hospital in
1975 (and again in 1977, since when she has remained in
residence), and that must have been a particularly risky
period for her. The small collages she made then, such as
Spirit Going Back to Its Home and Now That You Died
(both from 1975) had a febrile naivete about them that
pierced the viewer's heart and caused him to wonder if the
artist hadn't lost the power to go on living. And precisely
because of that, this same viewer can't suppress a cry of
astonishment at the overpowering explosion that followed.
The vividly coloured forms and silvery objects, some as tall
as ten metres, inundate the space, and an extravagant and
gorgeous banquet of life is laid out before us. She who came
so near to death has found a way to survive through her
art. And what a splendid survival it has been! Her art has
gone far beyond the level of mere self-healing…*

*Yayoi Kusama has emerged gloriously victorious in
the battle she has been fighting for more than half a century.
In recent works, such as My Solitary Way to Death (1994),
in which a ladder stretches into infinity between a mirrored
floor and ceiling, it's as if she has already attained a state in
which there is no fear even of Thanatos. In that sense, let
us repeat: This retrospective is a monument to the dazzling
victory of Yayoi Kusama, artist. Not mental patient but
artist – and an indisputably great one…*

*No one is further removed from 'the sentimental life'
than Yayoi Kusama. A self that experiences sentiment is
a given. But in the case of Yayoi Kusama, that self has been
transformed into an unindividuated space where a battle
is being waged against illness and death. There is no per-
sonal life there – only a life that has been unearthed in
a touch-and-go battle with death. The record of that ghastly
and gorgeous struggle, while possessing a heart-rending
poignancy, has also an intensity that would surely over-
whelm even those who are completely unaware of her
history of illness. All of her pieces soar to a place so far from
sentimentality that the mere sight of them can be chilling.
And that's why they're worthy of being called Art. Yayoi
Kusama, through her art, overcame the seduction of death
and lives on in righteous solitude. Gazing after her as she
walks off alone, a mass of wounds, all I can do is offer my*

—

deepest, heartfelt respect.
(Akira Asada, *Nami,* July 1999)

Even as the retrospective was going on, I was holding countless exhibitions of new works at museums, galleries, and art fairs around the world. This feverish pace resulted in what the press called 'Kusamania' or the 'Kusama Renaissance'.

For an exhibition of new work at the Robert Miller Gallery in New York, which ran concurrently with the retrospective at MOMA, I placed ten life-size reproductions of the *Venus de Milo* in a circle inside the gallery space. I had painted the Venuses with pink nets, and pink net paintings covered the walls in the background. The body of Venus, the paragon of physical beauty, disappeared among the nets.

From January until March 2000 I held a three-month solo show at the Serpentine Gallery in London. Then, in November 2000, a travelling show of new installations, called simply *Yayoi Kusama,* was launched at the Dijon Museum in France before going on to such venues as the Japanese Cultural Centre in Paris, Les Abattoirs Museum in Toulouse, the Odense Museum in Denmark, and the Kunsthalle in Vienna. The exhibition travelled to a total of seventeen locations, and the number of visitors at each was extraordinary. I put together the installations at each venue, using all sorts of materials in all sorts of variations – mirrors, black lights, balloons, coloured lights, and so on – so that the exhibitions were bursting with experiential delights. The rooms gave such pleasure that people would enter one and not want to leave; sometimes there were so many visitors that it was necessary to limit admission.

With my work receiving such recognition around the world, in 2000 the Japanese government presented me with the fiftieth Education Minister's Encouragement Prize and Foreign Minister's Commendation. And then, in 2001, I was given the prestigious Asahi Prize, presented by the Newspaper Foundation for Education and Culture.

To Make Art that
Will Last Forever

Each year for the past few years I have received invitations from four or five museums overseas to hold solo exhibitions, and I am compelled to produce new works constantly in order to keep up with demand. This is not a problem for me, however, since new ideas naturally come welling up every day. I always keep a sketchbook and coloured pencils at my side. Even in the middle of the night, if an idea comes to me I grab my sketchbook and draw. And each day I do a tremendous amount of work. New ideas and new visions of things I want to create are always percolating and swirling around in my head, in no particular order. All I can do, in the limited time left to me, is to turn these visions one by one into concrete forms.

The more I become engrossed in a project, the faster the days fly by. Lately it is as if time were jet-propelled. No longer young, I have come to regard each day as precious. But ever since my teens I have rued the passage of time and impatiently scolded myself for any idleness.

How does my present situation compare to the bustling restlessness of my teens? Now I am more keenly aware of the time that remains and more in awe of the vast scope of art. *O Time: hold still awhile. I have so much more work to do. There are so many things I want to express.* But time just keeps ticking away, and the earth never for an instant ceases to turn. I and so many comrades from the old days in New York – Johns, Rosenquist, Oldenburg, Marisol – have all flown high, and now the landing strip is in sight. This is the reason we are all producing works so fervently. We are like jet planes making our final approach – and when we touch down, the journey will be over.

That's why I intend to keep on creating, right here in Japan, new and unprecedented worlds and ideas. Even if the work before me were to require four hundred years to complete, I would begin this very moment – that is how I feel.

I think I can honestly say that this is the best time of my life. I am able to create works in rapid succession, and these past few years I have

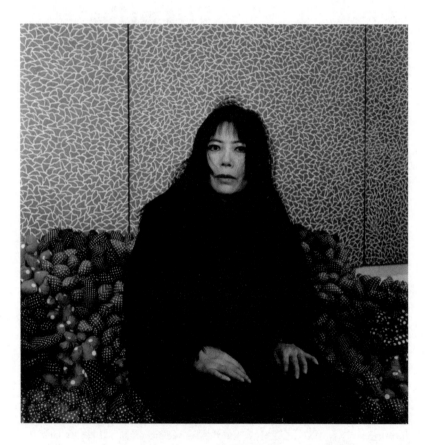

At *Yayoi Kusama* exhibition
Fuji Television Gallery, Tokyo
1990

produced a tremendous number of pieces. It is not as if I am enjoying myself in the process, however – no more than a soldier enjoys going to war. I definitely feel I have chosen a difficult line of work in life, and sometimes my own destiny leaves me appalled and exasperated. And I suspect that it is only going to get more difficult from now on.

Physically, I am always exhausted. Sleep is my greatest pleasure. When I am awake, I suffer endless aches and pains – my hip hurts, my feet hurt, my head hurts. I am a walking mass of physical complaints, and I plaster compresses on every creaky joint and sore muscle. I go for acupuncture and moxibustion, I get massages, and every day I walk to Kagurazaka – a thousand steps. Maintaining health is of the essence, and I often have to berate my own reluctant body. It does not matter how many ideas you have if your body cannot do the work.

I have no connection to the art world now. I have long been out of touch with my painter friends. I just dig ever deeper into myself. I receive invitations to numerous openings but never go, and therefore associate with no one. I am not a member of any committees or organisations. I do not speak with anyone in the art scene, nor participate in it. I neither drink nor smoke. I have absolute self-control and am completely absorbed in the creation of my art. And I live one day at a time.

I believe that the creative urge in art is born of quiet, solitary contemplation and takes flight from the silence of the soul's repose in the form of rainbows of shimmering light. Nowadays, the main theme of my work is death.

The arrogance of human beings, who have progressed so far through science and the mastery of machinery, has caused them to lose touch with the radiance of life and led to the impoverishment of the imagination. The increasingly violent information society, the homogenisation of cultures, the pollution of nature – in this hellish world, the mystery of life has ceased to breathe. The death that awaits us has lost its sublime quietude, and we have abandoned our claim to a peaceful end.

But beyond the ugliness of Planet Earth with its teeming, mindless cockroaches and rats, and beyond the degeneration of humanity, is the wonder of the sombre silver stars. The infinite instant of silence from billions of light years away is given life by an unseen power, a momentary existence in the midst of illusion!

My revolution of the Self, which has been such an essential part of my life so far, is all about discovering death. My destiny is to make art for my own requiem: art which gives meaning to death, tracing the beauty of colours and space in the silence of death's footsteps and the 'nothingness' it promises.

—

The elderly Joseph Cornell's words come back to me, spoken when I was still young: 'I'm not the least bit afraid of dying. It's just like going from this room into the next.' Being young, I thought of death as something outrageous and distant. It scared me. Now I can see that it is just as Cornell said: like stepping into the neighbouring room. Life and death are one and the same. I feel this as a certainty.

Lately I have frequently looked back at steps I have taken in life and muttered to myself: *I was right to do what I did that time.* But just as often, I think: *No, I should have done otherwise. Next time I'll improve. I must try even harder.* I have always had a plan for myself. From the time I was a teenager and had to endure the cold stares of those around me, my plan has been to live exactly as I wanted to. I have been able to do just that, and I am glad I chose the road I did.

Now I am planning even for after my death, writing proposals for how things should be done when I am gone. There is a limit to the life-span of a person, but art remains for future generations. People often say, 'Why think about death, when it's still well in the future?', but I cannot relate to such an attitude. It is never too late to be making plans, given the speed I have always maintained. Ever since my teens I have lived with one eye on the distant future.

What I think about first and foremost is that I want to create good art. That is my sole desire. It would be futile and meaningless to focus on the shrinking time-frame before me, or to think of my limitations. I shall never stop striving to create works that will shine on after my death. There are nights when I cannot sleep simply because my heart is bursting with the aspiration to make art that will last forever.

I feel how truly wonderful life is, and I tremble with undying fascination for the world of art, the only place that gives me hope and makes life worthwhile. And no matter how I may suffer for my art, I will have no regrets. This is the way I have lived my life, and it is the way I shall go on living.

—

—

—

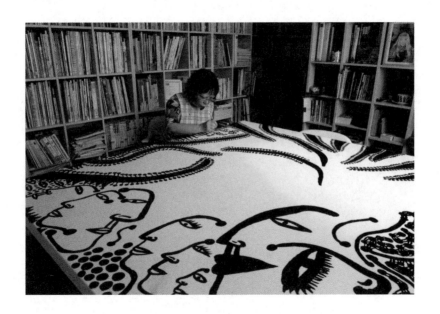

In my studio
Tokyo
2010

—

Poems

AFTER THE BATTLE, I WANT TO DIE AT THE
END OF THE UNIVERSE
—

I who have been shouting 'Love Forever' to all the people.
Having always been distressed over how to live
I have kept carrying the banner for pursuit of art.
And since the time I was born
I have continued running.
On the world stage,
constantly shedding my yesterday's clothes for new ones
I have kept creating an enormous body of work.
This 'journey' of mine, under the midnight lamp and
in the stillness of many sleepless nights, has been a source of
encouragement for me.
I want to shout love louder to the world and to leave my mark there.
To overcome conflicts, wars, terrors, and a morass of rich
and poor in the world,
that is my earnest wish.
May people live in peace
I never stop praying for that.
I want to keep fighting with the power of art.
With the pursuit of art as a cornerstone
I want to serve the people and contribute to society.
I will eventually grow old,
walk up a ladder all the way up to heaven in the vast universe.
In a bed of quietly floating white clouds
I depart from myself.
In a bed of deep and blue sky,
I will keep sleeping in comfort.
And I say farewell to the Earth.

—

RESIDING IN A CASTLE OF SHED TEARS
—

When the time comes around for people to encounter
the end of their life
After many years have passed, death seems to be quietly approaching.
It was not really my style to be frightened of that.
In the shadows of my loved one, distress revisits me
at the dead of night
refreshing my memories.
Being in love with and longing for you, having locked myself up
in this 'castle of shed tears'. Now may be the time for
me to wander out into a place
where the guidepost points to the nether world of life.
And the sky is waiting for me, attended by numerous clouds.
Overwhelmed by your tenderness that has always encouraged me,
From the depths of my heart, taking a path to 'my wish for happiness',
I have been searching all along
for the appearance of 'love'.
Let me call out to the birds flying about in the sky.
I want to convey these feelings to them.
Over many long years, I have treaded a path with art as a weapon.
But during those days I endured
and hid the countless 'despair', 'emptiness' and 'loneliness'
in my heart.
Along the way there were times
when the fireworks of life 'splendidly' adorned the sky,
dancing in the night sky in myriad colours.
I will never forget the exhilarating moment
when the fireworks sprinkled dust all over my body.
I would like to ask you
Was the beauty of the end of one's life nothing more than an illusion?
For having fulfilled my prayer for wanting to leave behind my
beautiful footprints,
this is my message of love to you.

—

AN ETERNITY OF ETERNAL ETERNITY

—

Whenever I tackle the fear of death that threatens me
everyday, I overcome it
by calming myself with all my might, and
discover my aspirations for art
The sensation of having been born into this world
has regenerated my life with a storm of new creation
The deep mystical whisperings of the earth
by providing salvation for my miserable, suicide-prone life
have dispelled my fear of and yearning for death
and always awakened me to the glorious brilliance of life
I am deeply touched by what living a life means and
by the glory of being alive
The joy of having realized that human life revolves eternally
Conquering the dreariness of death
and with the world's greatest art
I spend everyday determined to seek the magnificence of humankind
I want to live, to my heart's content
Let's make art shine radiantly
As long as I live, through the brightness of eternal life and death,
And the far reaches of eternity
I want to continue struggling
with an indestructible aspiration to reach a place where peace and
humanity prevail
And I want to tell the people across the world:
Stop nuclear bombs and wars, now
Live your shining life
I sincerely hope that you will look at the works I have created with my
utmost strength
And yearning for an eternity of eternal eternity
Let's sing a song together in praise of humanity facing the universe.

My Books

—

*The Hustlers Grotto
of Christopher Street* (includes
the title novella, *Prisoner
Surrounded by the Curtain
of Depersonalization*, and *Death
Smell Acacia*), Kadokawa
Shoten 1984; reissued by Jiritsu
Shobo, 1989

—

*The Burning of St Mark's
Church*, Parco Shuppan, 1985

—

Between Heaven and Earth
(includes the title novella
and *Garden of Women*), Jiritsu
Shobo, 1988

—

Woodstock Phallus Cutter,
Atelier Peyotl, 1988

—

Aching Chandelier, Atelier
Peyotl, 1989

—

*Sorrow Like This: Collected
Poems*, Jiritsu Shobo, 1989

—

Double Suicide at Cherry Hill,
Jiritsu Shobo, 1989

—

Angels on Cape Cod, Jiritsu
Shobo, 1989

—

The Foxgloves of Central Park,
Jiritsu Shobo, 1991

—

Lost in Swampland (includes the
title novella and *The Meadow
of Abandoned Children*), Jiritsu
Shobo, 1992

—

New York Story (includes *New
York AIDS* and *Downtown*),
Jiritsu Shobo, 1993

—

*The Psychological Hospital
of Ants* (includes the title
novella and *Bisexual*), Jiritsu
Shobo, 1994

—

Violet Obsession, Sakuhinsha,
1998

Index